The Complete Book of
DRAWING
TECHNIQUES
A PROFESSIONAL GUIDE FOR THE ARTIST

The Complete Book of
DRAWING
TECHNIQUES

A PROFESSIONAL GUIDE FOR THE ARTIST

BARNES
& NOBLE
BOOKS

NEW YORK

This edition published by Barnes & Noble, Inc.
by arrangement with
Arcturus Publishing Limited

2004 Barnes & Noble Books

Copyright © 2003, Arcturus Publishing Limited

M 10 9 8 7 6 5 4 3 2 1

ISBN 0-7607-6193-0

Jacket design by Alex Ingr

Printed in China

Contents

Introduction

Drawing, just like writing or speech, is a form of communication, and in the same way as these other forms of communication drawing can be multi-faceted, and very diverse as a means of expression of our observations, thoughts and feelings. Across the broad field of art and design, artists and designers will use drawing as a specific tool for visual communication, and at the same time use a wide spectrum of drawing techniques to express, develop, and present their ideas and work to the viewer for what ever reason.

Therefore, it is impossible to make a drawing unless the artist has a clear understanding of the type of drawing that is to be created, and the visual language that is to be used which will give form and expressive dynamics to the drawing. This is often forgotten or misunderstood by most teachers of drawing.

FIRST ENCOUNTERS WITH DRAWING

Usually our first encounter with drawing is to try to copy something from observation; this could take the form of a portrait, still life, or a landscape. When we're children we draw our observations from memory, and when we become more life experienced, we tend to draw direct from observation. This is normally when we encounter our first problems with the art of drawing, as we have fixed in our minds that to be successful with this skill our rendition of what we see must be nothing less than perfect. Usually these students of drawing that have this particular approach, those who seem to be chasing a visual truth through drawing, end up frustrated and feel a sense of failure. We cannot reproduce reality, we can only make a mark or a statement that acts for that reality, or a mark or a statement that best suits our purpose to describe that reality, and this is

known as a metaphor. Instead of chasing the idea of truth, what we should be doing is embracing the medium of drawing and using it for a purpose that fulfils our needs as an artist or designer. Let me now explain how we can break down our understanding and use drawing to facilitate our needs. As I have said before there are many reasons for us to want to draw, and there are many techniques and attitudes for us to adopt that will serve our purpose with the medium of our choice. What follows is a list of the reasons for us as students or beginners to make drawings. When using this book you should first identify the reason why you wish or need to do the type of drawing you are going to do, and then turn to the appropriate chapter in the book. That will give you the technique for the medium, and the knowledge you need to make the drawing.

REASONS FOR DRAWING

1/ First Thoughts

One of the many approaches to drawing is to use it as a tool to record our first thoughts. These usually take the form of sketches and drawings that have immediacy to them. They are usually spontaneous and inspirational as one is drawing one's thinking process as it happens. This process can initiate new ideas. This procedure is usually done in sketchbooks or on scrap pieces of paper, and they are usually presented as sheets of ideas. These types of drawings are then kept and developed into something more substantial as a statement in the future when our thoughts on the subject are collected and developed into a finished idea. Many artists from different disciplines have used this process of working and thinking through drawing as a way of developing their initial ideas. They range from Michelangelo,

Raphael, da Vinci, Rembrandt, right up to the present day and the designers of the Disney films.

2/ Research and Information gathering

Artist and designers use drawing research as a way of gathering information on a given task, or subject, that they have either been commissioned to do or one they have decided to perform for personal aesthetic reasons. Research is usually done in sketchbooks, and in specific places that hold the necessary information. These places could be museums, libraries, galleries, in the studio, or out in the field. It all depends on the type of research that is needed for the project in hand. Research can contain all types of information for the artist from shape, form, texture, diagrammatic information, techniques, recording fact, and so on. This type of work is usually completed through drawing, and note taking. Information gathering is the same as research but is done constantly by the artist as a visual resource. It is a visual dictionary that can be used at any point for reference, and all artists should continuously be gathering this type of visual information and storing it for future use. Information gathering is broader in its subject area than research as it includes anything of visual interest to the artist. If you look at some of the drawings by Leonardo da Vinci, you will see the enquiring mind of the artist, gathering information continuously from nature and science. Information gathering exemplifies the enquiring mind that sustains an interest in the visual world.

3/ Diagrammatic Drawings

These type of drawings are usually instructional, for example a map e.g. when someone needs directions we will draw them a very crude map that gives them an idea of where to go. Diagrammatic drawings have also been used in different cultures to enable us to read and understand religious or philosophical meanings, and aspects of that culture. Simple examples of diagrammatic drawings come with self assemble items such as furniture, models, and other forms of equipment!

4/ Theoretical Drawings

Theoretical drawings are important in the history of art in that they give us a means of understanding proportion, and space through the use of analytical and theoretical devices. These drawings are usually referred to as projection systems such as perspective, planometric, isometric, trimetric, and proportion and measurement drawing systems. This theoretical drawing base is applied to human proportion, architectural plans, and drawings from nature.

5/ Copies

Copying consists of absorbing the manner in which other artists have worked using the medium of drawing. In the following chapters in the book, copying is used extensively. It breaks down and assists our understanding of the drawing process. It is used to aid us in our learning, and to understand more fully the language of drawing.

6/ Drawing from Nature

All artists draw from nature whether it be a direct transcription or a drawing that is from memory. Drawings from nature include drawings of still life, drawings of the human form, or drawings from the environment or landscape. What we must realise is that when drawing from nature we must have a clear idea what we want to achieve from this drawing, how we want to approach it, and the type of language or technique we are going to

use to make the drawing. Students and beginners often forget this, and not to be equipped with this in mind is like starting out on a journey and not knowing your destination. When drawing from nature our aims should be to identify drawing techniques that are a visual parallel to the subject we have chosen to draw. In the following chapters in the book, I constantly refer to many approaches and techniques that will enable you to make drawings of nature. Historically artists have constantly drawn from nature especially as a information gathering exercise to fill their minds with visual knowledge that is stored for future use.

7/ Presentation Drawings
This is usually referred to by its Italian name, the Modello. These drawings are usually for a patron or are a commissioned piece of work. They are also referred to as artist's impressions. Their aim is to give the patron an idea of what the finished work will look like. Both the artist and the patron can reach an agreement before the main piece of work is started. These serve the purpose of preventing mistakes being made, sometimes at great expense to the artist or patron.

8/ Calligraphic Drawings
In calligraphic drawings, the artist has a repertoire of marks that act as signs or symbols for cultural meanings. As students or beginners of drawing we should develop an inventory of marks for the different mediums that enable us to express our ideas, observations, and feelings. We should experiment with making marks, lines, shapes, tones, textures, and so on. These type of experiments with the various different mediums are evident in the chapters in the book, and they are an extremely important part of our experience when starting to draw, so do not

over look this element in the drawing process. Calligraphy has developed from strict cultural traditions and the earliest known examples are from Persian and Chinese cultural draughtsmanship. In these cultures, strict traditions and practices had to be learned and followed in the execution of a drawing.

9/Drawing in its own right
Drawings in their own right are drawings that are made deliberately or solely for their own aesthetic reasons. However, illustrations can be put in this category, as they can act independently or support text. When connected with text, illustrations bring a visual quality to the experience that stands on its own merits.

This book has been put together in a unique way, as it brings about for the beginner and the student of drawing not only the techniques, but also the analytical and emotive approaches and attitudes to drawing. These techniques and approaches are then linked to the appropriate mediums for execution. However, one should only be guided by the projects in the book as starting points for your experience with drawing. Whenever you feel bold enough to engage with your own ideas and developments then you should embrace them with endeavour and gusto. Breaking with traditions, techniques, and theories is the hallmark of the true artist.

Finally, I would like to acknowledge Philip Rawson and his book on 'Drawing', and Dubery and Willats 'Perspective and other Drawing Systems'.

Part One

THE PENCIL

The different types of pencil, graphite, erasers.

INTRODUCTION

A pencil is a rod of graphite encased in a soft wood such as cedar, about six or seven inches long and exposed at one end. Crude forms of graphite pencils were first used as early as the 17th century. Before this, rods of lead or silver (known as silver point) were used as implements for making drawings. The modern form of lead or graphite pencil with its wooden encasement first came into use about the beginning of the 19th century.

The pencil fundamentally works by pushing or pulling the lead end across the surface fibres of the paper, which act as graters, breaking up into small flakes. Pressure on the pencil pushes the flakes of lead into the fibres of the paper to leave a mark or trace.

Graphite, a form of carbon, also known as mineral black or plumbago, is the major constituent of the modern pencil. The softness or hardness of a pencil varies depending on the amount of clay mixed with the carbon. The softest varieties of pencil contain little or no clay. Artists and designers will use a range of pencils, varying their choice according to the effect they are trying to achieve.

As the graphite is worn away by use, it can be repeatedly exposed. This is done by the action of sharpening the pencil using a purpose-made sharpener or blade.

Sharpening and exposing the graphite should be regarded as an important act, because how it is done changes the type of mark you make with it. There are many ways of sharpening. A particular point produces a particular result. The artist should experiment to discover what is possible and how to make each type of pencil meet his particular needs at any given time.

The pencil can be used for a variety of purposes and, as with any material you use, you must be fully aware of its potentials and its limitations - different pencils and types are designed for particular uses. In the ensuing chapter some of these practices will be revealed with particular relevance to the appropriate pencil or graphite material.

The marks shown over the following few pages give some idea of the wide range of mark making possible. When you have looked at them, take each of the pencils in turn and see what marks you can make. Apart from being very stimulating and a way of opening your mind to new possibilities with your drawing, you will find it increases your 'feel' for the pencil itself. As artists, what we feel through the materials we use has an affect on what we produce, and familiarity with those materials is vital to a good outcome.

Materials and examples of marks

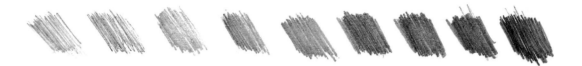

HARD PENCIL

Hard pencil marks have very little variation in the range of mark making. They only usually vary through a linear progression. Tone is usually made from a build up of crosshatch effects. Hard pencils are denoted by the letter H. As with soft pencils, they come in a range, comprising HB, H, 2H, 3H, 4H, 5H, 6H, 7H, 8H and 9H (the hardest).

These pencils are mainly for use by designers, architects and people who produce precise technical diagrammatic drawings for which a fine, accurate line is essential, such as perspective or other projection drawings. Although the marks made with hard pencil show very little variation it can be used in an expressive manner. As with soft pencil, tone can be built using a cross-hatching system, although the result is much finer and more formal, the cross-hatching emerging out of a series of linear progressions.

SYSTEMS FOR HARD PENCILS

Hard pencils are mostly appropriate for drawings requiring accuracy. As we have pointed out previously, such drawings are usually done by engineers, industrial designers, graphic designers and architects. The final drawings they produce have to be to scale and precise so that other people, such as craftsmen, can follow the instructions to construct or make the designed object. These drawings come in a number of different types of perspective, or parallel projection systems, ranging from flat orthographic plan or elevation drawings to 3D perspective illustrations.

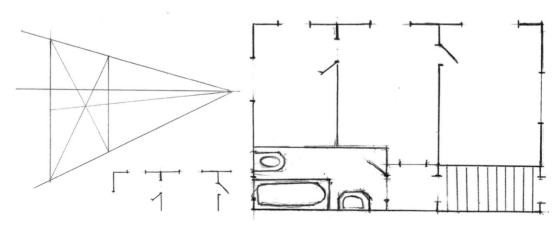

HARD PENCIL MARKS
NB: I have not given you examples of mark making with HB or 7H to 9H pencils.

6H: Vertical lines.

Horizontal lines.

Vertical and horizontal.

5H: Diagonal lines . sloping left

Diagonal lines with left and right emphases.

Diagonals with horizontal and vertical lines.

4H: A zigzag line.

Horizontal line achieved with the side of the point.

A combination of the previous marks.

3H: Dragging the side of the pencil horizontally in rows of zigzag lines.

Spaced dragged dashes.

Herring-bone pattern.

2H: Rows of squiggly textured. lines

Horizontal and vertical lines, producing a knitted texture.

Wavy horizontal lines.

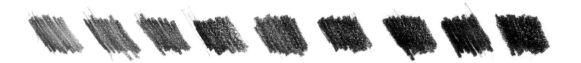

SOFT PENCIL

The soft pencil has more versatility for creating tone and textures than the hard pencil. Soft pencils are denoted by the letter B. The HB pencil is a mixture of hard and soft and is the pivotal pencil between the two extremes. The range of soft pencils available consists of HB, B, 2B, 3B, 4B, 5B, 6B, 7B, 8B and 9B (the softest).

These pencils are designed for the fine artist to express particular ideas, for example through the building of tone, the creation of texture, cross-hatching or even just simple line. Pencils at the softest end of the range can be used to produce blocks of tone. A graphite stick is generally more useful for this type of work and for producing larger areas of tone For a small drawing - up to A3 size - a soft pencil is more appropriate.

The only soft pencil suitable for refined work requiring great precision - essentially the preserve of the hard pencil - is the fine clutch pencil.

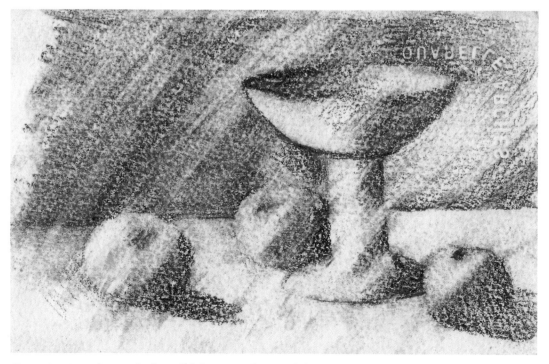

Drawing in soft pencil of a still life using observed directional light.

SOFT PENCIL MARKS

2B: *Horizontal rows of scribbled shading.*

Scribbled lines implying a knitted texture and shadow.

Vertical scribble, creating a soft texture and shading.

3B: *Heavy herringbone texture.*

Smudged tone (with the finger) to create atmosphere.

Random mark making implying a rough texture.

4B: *A pushed zigzag line using the side of the pencil.*

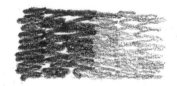

Rows of vertical scribble, progressing from dark to light.

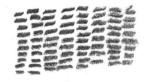

Regular dashes of tone.

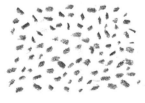

5B: *Irregular dots, creating an implied texture, perhaps a gravel path.*

Woolly scribble creating a textured surface.

Open zigzag lines create tone and texture.

6B: *Layer of graphite rubbed diagonally to create atmosphere.*

Vertical lines rubbed horizontally and then vertical lines drawn over the top to create a woven texture.

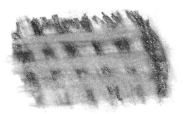

Tone rubbed vertically and then horizontally to create a woven texture.

OTHER TYPES OF PENCIL

Other types of pencil are available to us as well as those described above, and these offer even more opportunities for experimentation and discovery. You will find all of the types recommended below in any good art supply shop.

- Peel-back pencil - graphite encased, or coiled, in twists of paper which are peeled back to reveal the graphite.
- Propelling pencil - comes in a variety of mechanisms which reveal the point of the graphite.
- Clutch pencil - provides a very soft point (fine or thick) for sketching.
- Standard thick black pencil, known for many years as Black Beauty.

- Triangular carpenter's pencil - used by joiners and builders to mark measurements, make notes and sketch rough ideas.
- Graphite pencil or stick. The pencil type is solid graphite of about the same thickness as an ordinary pencil. The thin film coating on the outside edge peels back to reveal the graphite. The stick is a much thicker piece of graphite which, like a pastel, has a simple paper covering that can be removed as necessary. It is a very versatile fine art drawing implement.
- Aqua sketching pencil - these work like a pencil but can be used like watercolour washes when exposed to water.

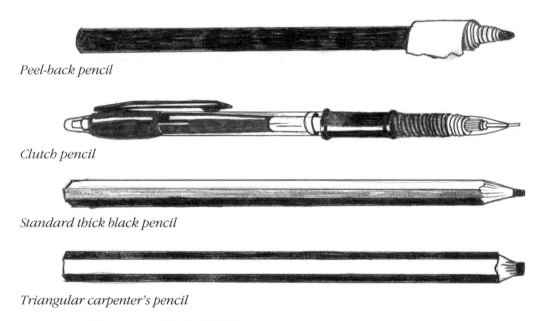

Peel-back pencil

Clutch pencil

Standard thick black pencil

Triangular carpenter's pencil

Graphite pencil or stick

Aqua sketching pencil

MARK-MAKING WITH OTHER TYPES OF PENCIL

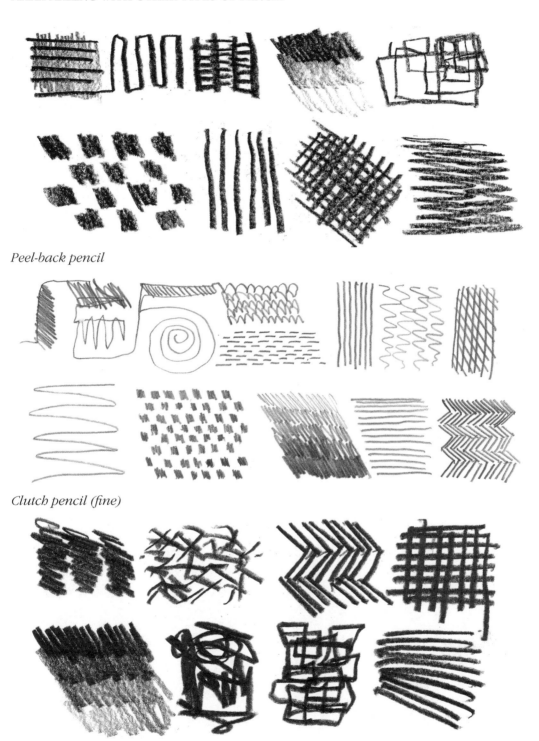

Peel-back pencil

Clutch pencil (fine)

Clutch pencil (thick)

MARK-MAKING WITH OTHER TYPES OF PENCIL

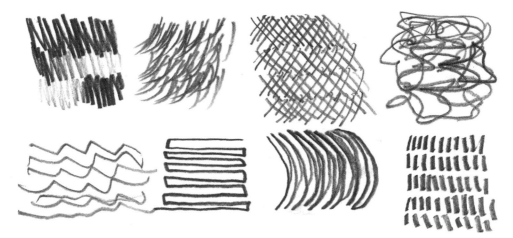

Black beauty

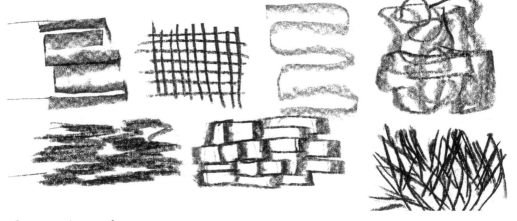

Carpenter's pencil

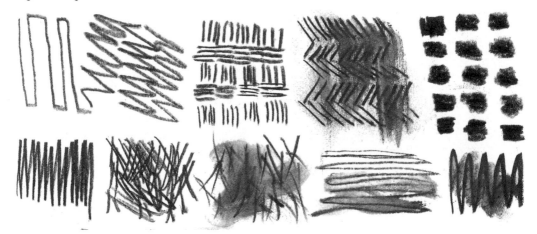

Aqua sketching pencil

GRAPHITE

Graphite is the same medium that pencils are made of. The difference being that pure graphite is not encased in wood. They are in fact solid lengths of graphite that come in different thicknesses and grades of hard and soft. As you might gather from the illustration this type of material is not meant for detailed accurate drawings. Instead it is more suited for robust drawings of an expressive nature, and it works well together with a plastic eraser.

The type of drawings we would produce with this type of medium would be quick, heavy, dramatic drawings using strong, dark lines, large areas of dark tones, or interesting textural marks. Mood is very easily effected with this medium, and it is definitely not suited for drawings of a technical nature. It is also more appropriate for larger drawings rather than smaller ones for obvious reasons. It is a medium that is very versatile, and before you start to draw with it in earnest you should experiment with the potential that the medium has to offer. Because it has no outer casing you can make so much more use of the side. You don't have this facility with the pencil, and you will be surprised at what you can achieve with this potential in terms of mark making. I personally always associate a very liberated and dynamic type of drawing with this material, and if you approach your drawing in this fashion with the graphite you will get the best results.

DRAWING WITH SOFT PENCILS AND GRAPHITE

Unlike the hard pencil, the soft pencil and graphite are designed to make a much heavier mark and to create a tonal range - from a very dense black through to white.

The soft pencil and graphite enable you to do this quickly and efficiently. The pencil will also allow you to describe shape and form, but you must keep the lead sharpened.

The types of drawings associated with these materials are more open and expressive by nature. They relate to our responses, our observations and ideas, and might be the sort of drawings we jot down in a sketch-book as a record of our first thoughts about a subject. They might be a part of our visual research and notation. They record a change of tone, either through observation or imagination, or imply a textural surface. They can be drawings which give an explanation or give expression in their own right (that is, works of art in themselves and not just supports for further work).

A useful material that can enhance the use of the soft pencil is the eraser, and the two work very well together to create expressive effects. Whereas when used with the hard pencil the eraser is associated solely with the elimination of mistakes, as a complementary tool to soft pencils and charcoal its contribution is entirely positive.

Different effects can be produced with soft pencils and graphite if you vary the amount of pressure you use. Pressure enables you to activate the surface of the picture plane, either by using tone or weight of mark. Look at these examples of creating tonal gradation and then experiment yourself. As well as varying the pressure, try to apply the material in as many different ways as you can find, using different movements and different areas of the material.

MARK-MAKING WITH GRAPHITE

Making zigzag markings.

Using a twisting movement with the graphite on its side.

Pulling and pushing motion.

Dragging movement.

Stabbing with the end of the graphite.

Lateral mark making.

Lateral and vertical mark making.

Vertical mark making.

ERASERS

Usually our first encounter with an eraser is when we use it to remove a mistake. Our sole aim with it is to obliterate the offending area so that we can get back to the business of progressing with our drawing. Because the eraser is associated with mistakes, a lot of negative feelings about it and its function are directed at it. The poor old eraser is seen as a necessary evil, and the more dilapidated it becomes with use the greater become our feelings of inadequacy. It really is time for a re-assessment of the eraser and its role in our work. Used effectively it can be one of the most positive tools at our disposal. But first we need to remove the idea that mistakes are always bad. They are not, and can be used as a positive element in your work from which you can learn.

Many artists make decisions about where things go, or how things should look, in a piece of work. In the first instance these statements are usually wrong and have to be adjusted as the work develops. This has happened to us all - even great artists like Leonardo da Vinci and Rembrandt. Re-thinking is very much a part of the creative process and is evidenced in many works, particularly in drawings where the artists are working out their initial ideas and intentions.

One of the major errors that beginners make is to erase mistakes as they arise and then start again. This puts them in a position of making more mistakes or repeating the same ones, thus creating a feeling of utter frustration and failure. When you make a correction, over-draw and don't rub out the original lines until you are happy with your re-drawing and unless you feel they don't add anything to your drawing. My personal advice would be to leave a ghost of the correction and not to erase it completely, as this shows the evidence of your thinking and your development.

Other positive ways of using the eraser are to bring back the areas of light in a tonal drawing which have been worked over with graphite, charcoal or ink. Erasers can also be used to make expressive statements and emphasize textural marks - powerful examples of this approach can be seen in the drawings of Frank Auerbach. The technique known as 'tonking', in which a cloth is used in a beating motion to knock back charcoal marks, is a superbly atmospheric form of eraser use.

There are many forms of eraser on the market which purport to remove all sorts of media from the surface being worked upon. Listed below are common types of eraser and some explanation of how they function.

• Putty rubber. Usually used for charcoal and pastel, it is also suitable for other materials such as pencil. The chief advantage of a putty eraser is that it can be kneaded into any form to erase in a particular manner. This is very useful for a positive approach to drawing and seeing the eraser as a tool which brings something to a drawing rather than merely taking something away.

• Plastic rubber. This type is designed particularly for erasing very dense graphic markings, and will also remove charcoal, pastel and pencil. It can be used to create

Tippex fluid.

particular marks which are determined by its shape.

• India rubber. Used for removing light pencil marks.

• Ink rubber. Ink marks are very difficult to remove entirely with a rubber. Erasers for removing ink and typewriting come in pencil and circular forms. You can also purchase a combined eraser that works for both pencil and ink, with the pencil part of the rubber at one end of the rubber and the ink part at the other.

• Surface removers, such as scalpels, razor blades, pumice stones, steel-wool and sandpaper, to remove the very stubborn marks found in pen and ink drawings. Obviously, before applying this method you must ensure that your paper is of sufficient weight and quality to allow you to scrape away its top layer without leaving a hole.

• Surface coverers, such as correction fluid, titanium white or Chinese white. With this approach any offending marks are buried under an opaque layer of white. When the layer is dry, the surface can then be reworked.

DANGER ARTIST AT WORK

Always remember that you need to work within health and safety guidelines when using materials. Scalpels and razor blades should always be used with care, and when they are not in use their blades should not be left exposed. Note too if any of the fluids you use are flammable or toxic. Bleach, for example, is a very handy and cheap method of removing water-based ink, but it is very toxic and must always be handled with care.

Tippex pen.

Chinese white.

A SELECTION OF ERASERS

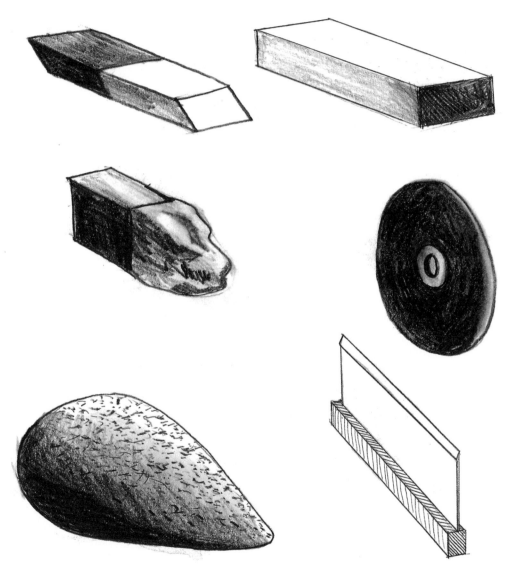

Pumice stone is useful for removing very stubborn marks, but it can damage the surface of the paper and so must be used with care.

A razor (or scalpel) blade can scratch away difficult-to-remove marks. It is an instrument of last resort because while removing the marks you don't want you may inadvertently damage other parts of your drawing.

Ways of holding the pencil

PRELIMINARY DRAWING
Breaking Down Preconceptions
Before we go on to discuss techniques in relation to drawing media, I want you to think about your input into a drawing from a psychological and physical point of view. When we start out along the visual creative road, we tend to bring with us a lot of preconceived notions about what a drawing is and how it should be produced. It's vital for your creative development that you shed these preconceived ideas as quickly as possible, otherwise they will continually hold you back.

One of the first projects I put before my students in the studio involves an exploration of our relationship with the drawing implement. We will assume, for our purposes, that this is a pencil. Breaking down preconceptions involves taking risks and trying something a bit different. If we are not careful the familiar can become a straitjacket, and this extends to how we hold the pencil. You might think, 'Well surely, there's only one way of doing that!' Wrong. There are several ways and each of them will tell you something new about the implement you are using and what you are capable of producing with it.

If you try holding your implement in experimental and unorthodox ways you will produce drawings that have a variety of expressive marks and various tensions within those marks. You will widen your approach to mark making, whether with a pencil or any other drawing implement, and also open up your attitude towards drawing techniques.

In the first stage of the project I ask students to make test samples and just see what sort of marks they can make by holding the pencil in a different way to usual.
Holding the pencil in a traditional way - this

way of holding the pencil for the beginner can be very restricting, as it tends to come with too many preconditions that limits our ability to be more creative. However holding the pencil in this way is very appropriate for more theoretical and technical drawing where you need more control.

Holding the pencil with your fingertips - this action changes the type of control, and it allows you to make marks that are more tentative. The pencil can also slip quite easily in this position, giving marks that are not accounted for, and therefore bring a life to the drawing that is more creative because we are allowing for the mistake or the slip to take a positive part in the drawing.

Holding the pencil like a dagger - this is the opposite effect to holding the pencil in your fingertips. As the mark made from this action is strong, direct and usually aggressive in its expression. The very physical nature of this drawing employs the movement of the whole arm rather than just the wrist and the hand.

Holding the pencil between the toes - I have seen some amazing drawing done by students in this position. Stand on one leg and don't hold on to anything whilst doing the drawing. Then place the board on the floor, put the pencil between the toes and proceed to draw.

Use the figure when doing these drawings. Treat them as experiments, and as fun - you will be surprised at the results.

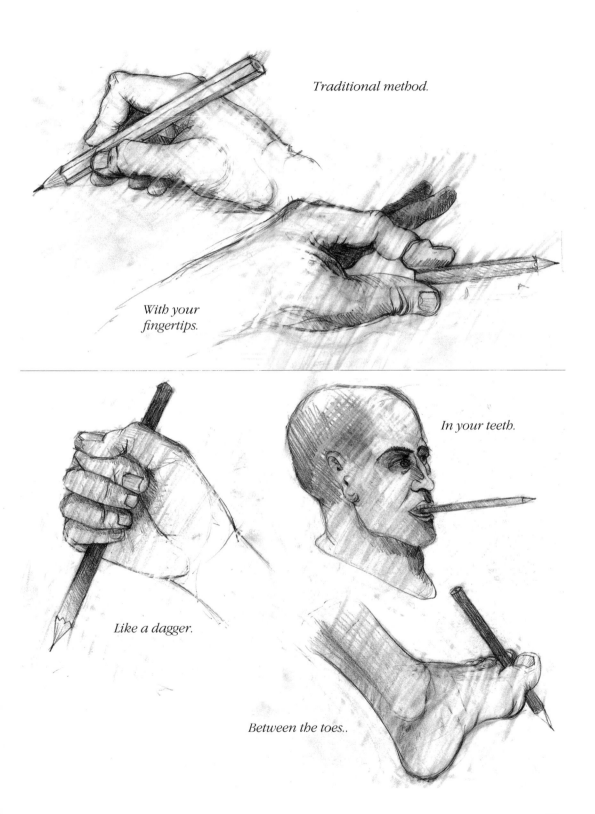

Traditional method.

With your fingertips.

In your teeth.

Like a dagger.

Between the toes..

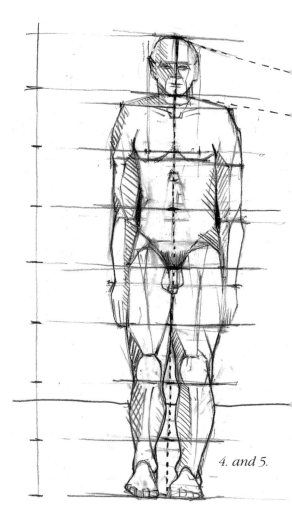

4. and 5.

THE PENCIL AS A MEASURING DEVICE

We can analyse our observations in a number of ways to enable us to make a visual record of what we see. One of these ways involves using the pencil both as mark maker and measuring device. What you are doing in effect is building a grid on which to map out your drawing. This approach is appropriate for all types of observational drawing and for different subjects ranging from landscape and still life to figure drawing. I have chosen a figure for our example because the pencil is still the most popular measure for this type of drawing; go to the life rooms of any art college and you will find it widely used. The procedure is as follows:

1/ Set yourself up for drawing in a fixed position so you have a consistent view that doesn't alter. This enables you to see the subject from the same viewpoint every time without any change occurring - vital if your measurements are to be accurate.

2/ Hold the pencil in the fist of your favoured hand, leaving your thumb free so that it can slide freely up and down the side of the pencil.

3/ Stretch your arm out straight towards your subject matter and take a measurement. This is always done on a vertical axis. For instance, if we are drawing a figure, usually the measurement will be from the top of the head to the bottom of the chin. Close one eye as you do this, to focus your vision and give you one viewpoint. Put the top edge of the pencil at the top of the head then pull your thumb down the pencil until you come to the bottom of the chin. You have now

established the proportion of the head. Repeat this process along an imaginary vertical down the body, using that first head proportion as your measure for dividing the figure. This will give you a proportional overall length of the figure - usually an average person will comprise eight head proportions in all from tip to toe.

4/ You can repeat this process to measure the width of your figure. Turn your pencil to the horizontal position and measure across

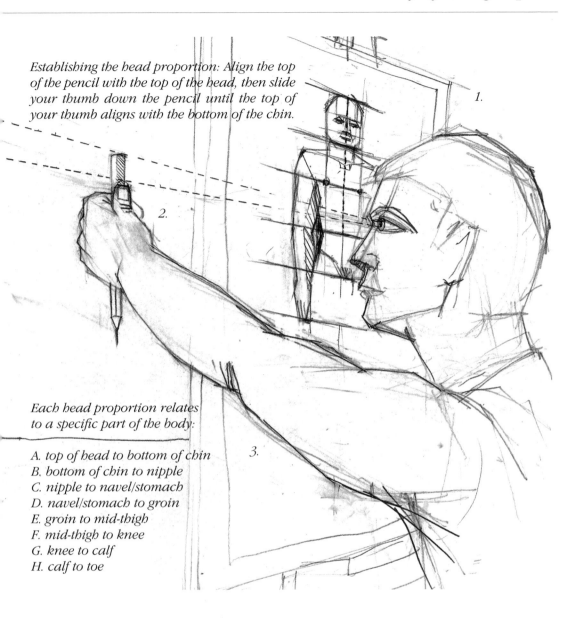

Establishing the head proportion: Align the top of the pencil with the top of the head, then slide your thumb down the pencil until the top of your thumb aligns with the bottom of the chin.

1.

2.

Each head proportion relates to a specific part of the body:

3.

A. *top of head to bottom of chin*
B. *bottom of chin to nipple*
C. *nipple to navel/stomach*
D. *navel/stomach to groin*
E. *groin to mid-thigh*
F. *mid-thigh to knee*
G. *knee to calf*
H. *calf to toe*

the figure, using the head proportion as your gauge. It is important to remember always to measure only on the horizontal or vertical axis - if you measure at an angle you will get distortions – and always measure with your arm straight out in front of you and from the same position to maintain consistency.

5/ Once you have your vertical and horizontal proportions, you can now transfer this information to your paper. If you wish, you can make what is called a 'sight size' drawing by using the exact measurements you have assessed. This does, however, usually turn out to be a very small, tight drawing, and is not advisable unless you are very experienced. The other way is to make a scaled drawing relative to your proportions; for example, if your original head proportion was one inch in height, you could double it when you came to transfer each measurement to your drawing.

POSTURE

Posture runs hand in hand with proportion. Posture is the way we hold ourselves and has a direct relationship to the changing nature of proportion. As you can see in the example opposite posture is informed by directional lines that are determined by the angles of the body and the relevant proportions in relation to your body when you are in a pose. Posture also allows us to understand and come to terms with the human form that exists in space on a two dimensional surface. The posture lines usually follow the central dynamics of the pose, and pick up the changing edges of the form on the main parts of the body. You should always give lots of consideration to how you pose your model, because the posture will say so much about your drawing and what you are trying to achieve through it.

One way of using postural lines is by extending them and in doing so one can find relationships that extend to other objects in a drawing. This is another way of making a drawing have proportional accuracy. It also creates an analytical directional tension in the drawing.

ASSESSING ANGLES

Posture is the way we hold ourselves and is intimately connected with proportion. As you can see in this example it is shown by using a directional line that determines the angles and proportions of those angles relative to the other relationships of the body and their changing angles. Posture lines usually follow the central dynamics of the pose through the figure. They also pick up the changing edges of the form on the main parts of the body.

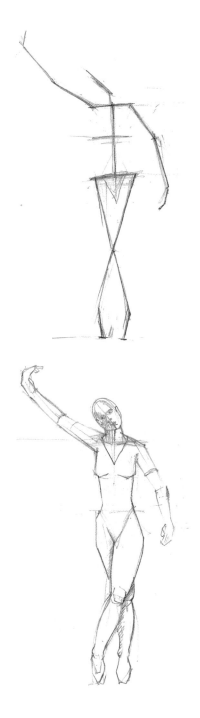

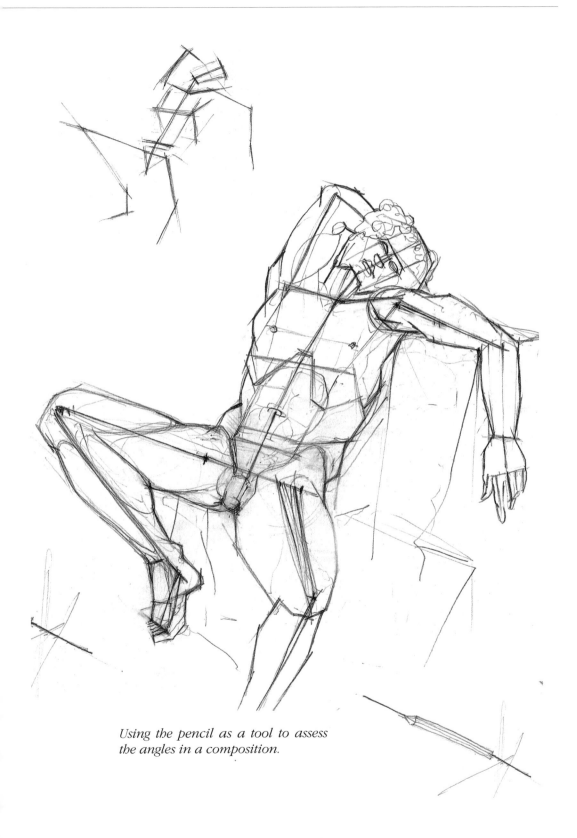

Using the pencil as a tool to assess the angles in a composition.

VECTORS OF ANALYSIS

This is another way of giving your drawing proportional accuracy. The aim is to find associations by extending the axis from the objects to locate other essential elements in the drawing.

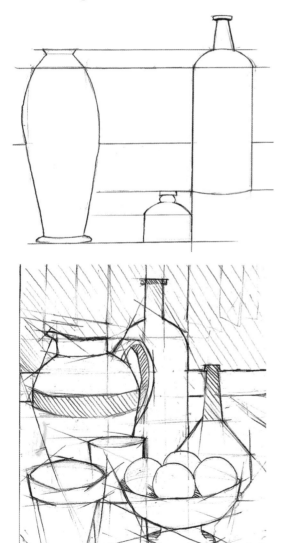

THE WINDOW MOUNT OR VIEWFINDER

Using a window mount is a marvellous way of composing your picture and getting the objects in the scene proportionally and positionally correct.

Cut the window to scale in relation to your paper. To do this and get accurate proportions in relation to your paper, follow these instructions.

Step 1/ Take the paper you are going to draw on and make a diagonal line from one corner to the other.

Step 2/ Decide how big you want your window aperture to be. For example, if you want the height of your aperture to be three inches, measure this length up the side of your paper from where the diagonal line departs.

Step 3/ From this point draw a straight line into the paper until it meets the diagonal line.

Step 4/ From the point where the line meets the diagonal line, draw a straight line to the bottom edge of the paper. You now have an accurate scaled proportion of your piece of paper.

Step 5/ Take the measurements of this proportion and draw them into the centre of a piece of card, then cut out the window for the viewing of your composition.

Step 6/ Mark the edges of the window mount and the paper into 1/2, 1/4 & 1/8. Some students string cotton across the window to make a grid.

If you do this draw a corresponding grid

on your paper. Put the window up to the world and choose your composition. Now you will find it very easy to transpose what you see through the window on to your paper.

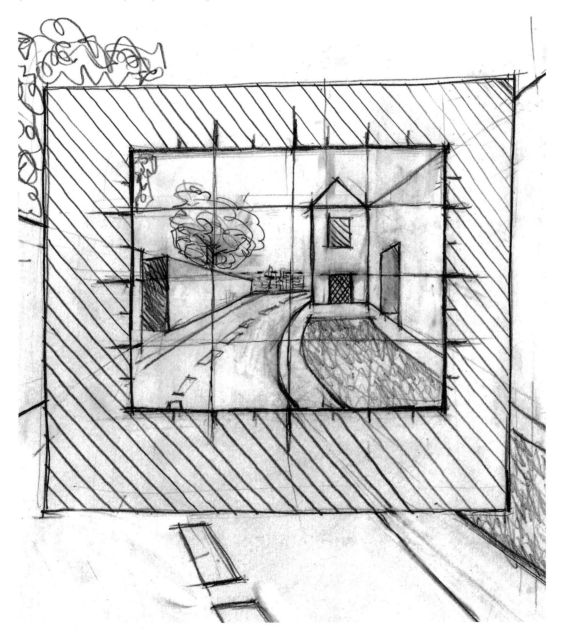

Pencil projects

Project One
DOODLES – FIRST THOUGHTS AND IDEAS

DOODLES

Doodles should not be thought of as drawings without meaning or drawings that have no importance or significance. In fact, they do, as many artists find other peoples' doodles fascinating. It's an important way of showing the unconscious process of creativity. Doodles are usually created with pen or pencil. They are usually a secondary part of our thinking process. For example most of us doodle when we are in meetings - it helps us to escape the boredom of the moment - and doodling allows us to descend into our own private world. We also doodle when we are on the telephone when we tend to use the phone pad as a sketch book. I believe there is a wealth of ideas that come from doodles so treat them as research.

FIRST THOUGHTS FROM OBSERVATION

Just like doodles first thoughts from observations are our initial visual response to what stimulates our thinking processes. Most artists always carry a sketchbook with them. It allows us to record moments that include landscapes, portraits, textures, architecture, nature, light, atmosphere, and so on. This is all visual research that is stimulation and a continuous resource for our ideas. Sketchbooks of artists are fascinating to look at, as in the sketchbook you can see the origin of ideas, and responses, that the artist is engaged with. One only needs to look at the sketchbooks of the artist Turner to realise what a wealth of information they hold.

FIRST THOUGHTS AND IDEAS

Many ideas start with a visual brainstorming. The artist or designer plays with the potential of their ideas in their sketchbooks. They make thousands of rough sketches continually changing and rethinking their ideas. Stretching the thinking and the dynamics of their designs to the limit. Designers work first with open minds, which allows for client comment. Before honing in on a final statement, all this starts with visual thoughts translated through sketches. All those ideas, even the redundant ones are left stored in the sketchbooks for later use. It's all visual information and that's what's important and exciting.

COMPOSITION: THE BASIC ELEMENTS

Shape can have a very intuitive influence. Only as we become more experienced do we become formally aware of how to construct a composition. Intuitively, the beginner will invariably place the mass of the subject (still life, portrait, whatever) in the middle of the picture plane. In 90 cases out of 100 this placement is a mistake, creating too much of a focal point and not allowing the eye to be taken on a journey across, and into, the rest of the picture plane. The composition is in effect becalmed, stale and therefore visually

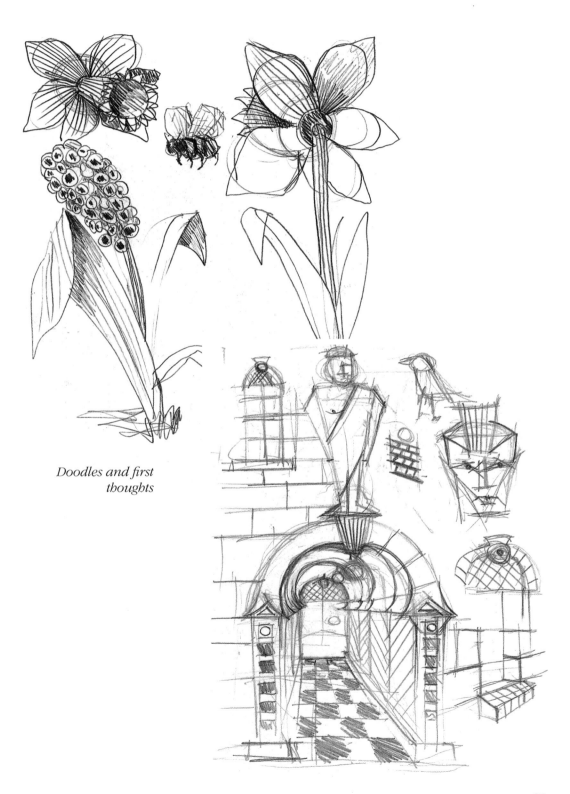

Doodles and first thoughts

uninteresting to the viewer. What we intend to do with shape in these projects is to give you basic experience in using hard pencils to create shapes that, when drawn on a picture surface in relation to each other, will create a good composition.

Sometimes this movement across and through the plane happens intuitively, but more often than not it is confirmed when you see an artist working and they step back from the picture and gesture towards their piece of work with arm outstretched, head tilted sideways and hand or thumb looking as though they are engaging with the picture in some way. This is when the artist is trying to contrive the composition.

Rhythm is very obvious in other forms of art, such as music, dance and writing. It is a sort of beat holding the work together. In a drawing or painting we can create a sense of rhythm that enables us to work harmoniously from one point in the composition to another. Rhythm can be evident in the use of tone, colour, mark and scale, but here we deal with it as it presents itself in shape.

ORDER AND BALANCE

In any given picture there are a series of tensions that must play off and counter each other so what we finish up with is a pictorial synthesis or a pictorial order. This is what is meant by a composition having a semblance of order and balance. If you look at most classical works of art, particularly landscapes by Poussin or Claude, you will see this quality in abundance.

MOVEMENT

The importance of movement through the picture plane cannot be over-emphasized. Shape and other pictorial elements help us to create movement. The artist can engage the eye of the viewer so that it moves across the picture plane, stop the eye at a certain point and then move it back into space, bring the eye forward again, and at the same time across the picture space, and then take the eye right out of the picture to the end of its journey. Most viewers are unaware of this visual encounter, which tends to occur within a few seconds of looking at a picture.

There are, of course, many ways other than the use of movement by which artists can - either consciously or subconsciously - enable us to read and understand their work. As well as creating these ordered harmonies and movements through and across the picture plane, the opposite effect can be created, especially if we want to achieve an expressive effect.

As beginners we tend to draw objects in isolation and in a void, so they look as though they are floating in space. For an object to have an identity, and speak to us as viewers, it must have a context. The artist does this by drawing the space around objects rather than by trying to capture the shapes of individual objects in isolation.

This very simple composition is made out of a shape that repeats itself, and yet it is imbued with a sense of time. We can see there is order and balance and that our eye is allowed to move freely through and across the composition. There is no ambiguity interrupting the flow. Movement is created by the illusion of the overlapping shapes moving across, down and back into the picture plane and our sense of the decreasing scale of the shape (perspective). The way the shapes fall injects a feeling of rhythm suggestive of the ticking of the second hand of a clock.

EXERCISES WITH HARD PENCILS

In this section, we are going to introduce you to a series of projects and exercises that will give you a practical introduction to using the range of hard pencils. As we have previously said, the hard pencil makes a fine precise line. What we shall show you is how that line can be employed to demonstrate your ideas, expressions and observations.

First, we must complete a series of exercises to see and experience what we can achieve with the material. In many ways these exercises are like the warm up routines that sportsmen and women go through before they take part in an actual event - by loosening us up they enable us to focus on the work in hand.

The next stage involves experimenting with the concept of shape, space and composition over the picture plane. This will further our understanding of how to build a composition: the type of elements a composition can contain (for example, harmony, balance, rhythm and movement), how these elements alter the eye's ability to travel over and into the surface of the picture, and how we read the picture in a more representative way. Finally, we explain the nature of diagrammatic and perspective drawings both from theoretical and observational approaches. We will show you how to develop these methods for use in your particular approach to drawing and to expand upon them whenever you feel it is appropriate.

Medium: 6H, 5H and 4H
As you will see, the types of marks or lines produced with these pencils are quite

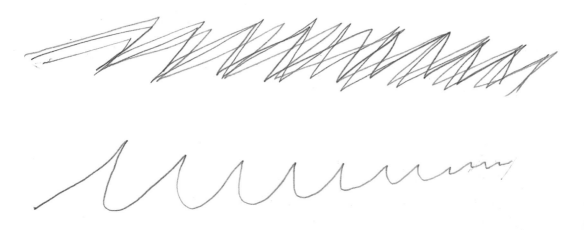

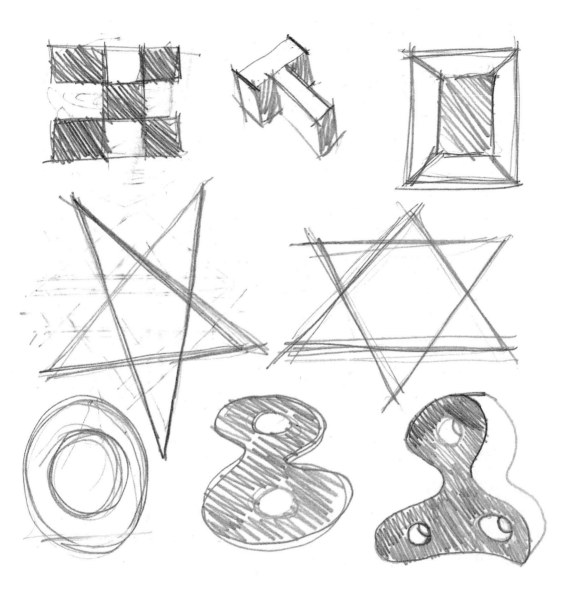

similar and lie within a close range. The fineness and hardness of the line suits precision drawing, such as architect's plans for example. I personally would not use them to build up tone, because the contrast you can produce with them is limited. However, this is a personal opinion. There are no hard and fast rules in art, and if it suits your purposes to work tonally with pencils in this range, then by all means do so.

Medium: 3H, 2H, H and HB
When you start experimenting you will notice that the marks are more intense tonally than was achievable with the previous set of pencils. You can still make very precise lines, but at the same time clearly develop the weight of the mark, and bring more expression and life to what you are doing. These are ideal implements for putting down your first thoughts and making subconscious 'doodles'.

SHAPES AND FORM

In this next section we are going to look at shape and turning shape into form.

The definition of shape is that it has perimeter and lies flat upon the picture plane unless we relate it to other shapes which can then imply space. It is a very useful exercise to practise drawing shapes – squares, circles, triangles, rectangles and any type of organic shape. It is also useful to practise turning shapes into illusions of form; for example, making a circle into a sphere, a triangle into a cone, an oblong into a cylinder. These exercises are essential for the beginner.

Medium: 6H, 5H, 4H, 3H, 2H, H and HB
Next we are going to draw shapes - shapes that will imply meaning in a non-representational way and will create tension on the surface of the paper. The shape contains the essence of any composition - a combination of harmony, balance, rhythm, movement and spatial implications. These are the basic components that hold a drawing together and the dynamics that a composition needs to express an idea. The interrelationships between them are key to the making of a successful drawing. In the sketches that follow we will be playing with these interrelationships.

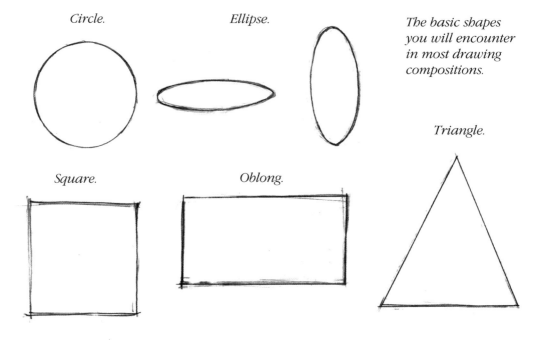

Circle.

Ellipse.

The basic shapes you will encounter in most drawing compositions.

Triangle.

Square.

Oblong.

PRACTISING SHAPE INTO FORM

Now practise turning shapes into the illusion of form, so the circle becomes a sphere, the triangle a cone, and the oblong a cylinder. We need to understand the properties of shape and form, and how artists use them to create a composition. Without a sense of form you will not be able to produce a finished piece of work.

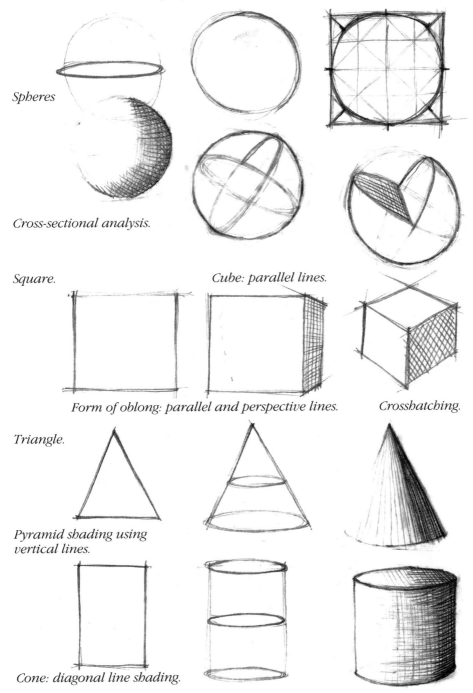

Spheres

Cross-sectional analysis.

Square.

Cube: parallel lines.

Form of oblong: parallel and perspective lines.

Crosshatching.

Triangle.

Pyramid shading using vertical lines.

Cone: diagonal line shading.

POSITIVE COMPOSITION

Shape as an underlying compositional device is extremely important. In this example, after Malevich, shape is used to bring a sense of order, balance, rhythm, harmony, movement and space to the picture plane. We see the bones of the composition that any great picture has as its structure. We can compare this drawing to Gericault's *Raft of the Medusa*.

Both have an underlying triangle that appears to pull the eye upwards to the top edge of the picture plane. This triangle is the base on which the rest of the picture hangs and the device that holds it together. All activity in the picture revolves around this basic structure and helps to move our eye through the picture plane from bottom to top, and back and forth.

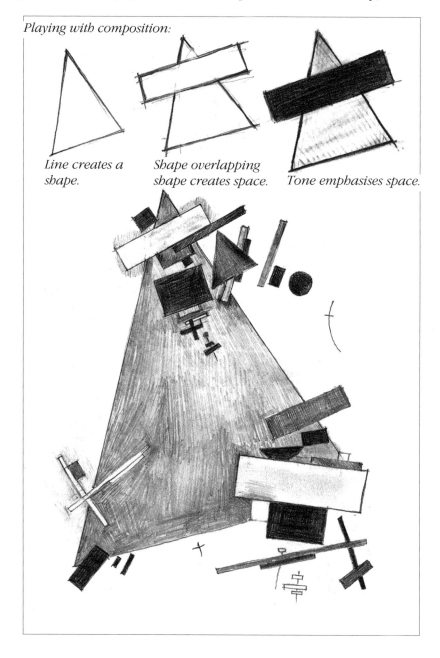

Playing with composition:

Line creates a shape.

Shape overlapping shape creates space.

Tone emphasises space.

Malevich

As our eye moves upwards, we get a feeling of hope and lightness, while down at the bottom of the picture plane we are seized by a sense of falling and despair. Note also a sense of space that gives the illusion of movement through the picture plane. This is created by scale and weight of mark. The space is constructed by overlapping shapes to create distance.

This drawing, after Miro, gives us a completely different feeling from the Malevich. The composition is based on the organic flow of shapes. There is more fantasy, almost a dream-like quality. The organic shapes and the sense of texture suggest that the picture is growing and expanding before our eyes.

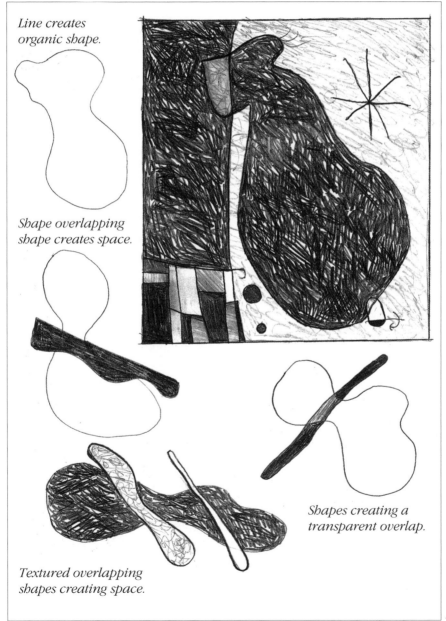

Line creates organic shape.

Shape overlapping shape creates space.

Shapes creating a transparent overlap.

Textured overlapping shapes creating space.

Miro

COMPOSITION: NEGATIVE SHAPE

With the Malevich and Miro copies, we have been looking at examples of positive composition, drawing shapes of objects we have in mind and placing them to create an effect. A different way of understanding shape is to draw the space around the positive. This is called the negative space, and is a very effective way of creating relationships between objects in a drawing.

SUNFLOWERS AFTER VAN GOGH

When analysing the drawing of sunflowers after Van Gogh I can see quite clearly how important the element of shape is to this piece of work. The negative shape, or the shape around the flowers in this composition is just as important as the flowers or the positive shape, and it is integral in holding the composition together. The negative shape underpins the composition and helps the sense of harmony, balance, proportion, and rhythm that gives the picture its wholeness. Through the negative space, the subject becomes locked into its context.

Here we have in these two drawings the first two layers of negative shape, which establish the subject in its environment or context.

Set up a still life of flowers on a table that is put against a wall. Then set up as if to draw, with your pencil, paper and an eraser. Now take a viewfinder or what we know as a window mount and frame the composition of the flowers. We are going to copy the composition in the window mount and place it on our paper, by mapping the composition using the negative space.

HOW TO START

In the first example you will see that what we have drawn what appears to be a silhouette over the top of the flowers. Do this by starting at the paper's edge on the left hand side, as it is important to make your first connection with your drawing at this point. Start to progress the line towards the centre of the paper following what would be the line that

would indicate the back edge of the table where it touches the wall. It is now important to try to assess how far that line goes into the paper before it encounters the vase that holds the flowers. Do this by looking through your window mount again, remembering to look through it in exactly the same position every time. The window mount should be proportionally marked as showing halves quarters, and eighths as seen in the example on window mounts. One should mark ones drawing off in the same way, as we can use these as guides to indicate where objects are situated in the composition.

One can now begin to make an assessment as to how far that line travels into the picture by using these proportions. Let's say for this instance it is about a quarter of the way in. We would then translate that observation from our window mount to our drawing allowing the line that we first started with to travel into the drawing a quarter of the way, where it would then engage with the vase. Now the line would start its journey around the vase being monitored for proportion in the same way, firstly observing and making your proportional calculations through the window mount and then transferring these observations to your drawing. Eventually the line will complete its journey to the other side of the paper, splitting the paper in two as you can see in example 1.

In example 2 you will restart the drawing in exactly the same place over the top of your first line. However, when it engages the vase this time the line will detour around the bottom edge of the vase, and it will progress following the outline of the vase until it reaches the other side of the paper. This part of the drawing should be easier to accomplish as the first part of the drawing will help you in your understanding of the second part of the drawing and so on. The drawing as in example 2 will now contain three sections to it rather like a simple jigsaw construction. The first being the top half of the silhouette, the second being the bottom part of the silhouette, and finally the overall shape of the objects that are contained in the composition i.e. the vase and the flowers.

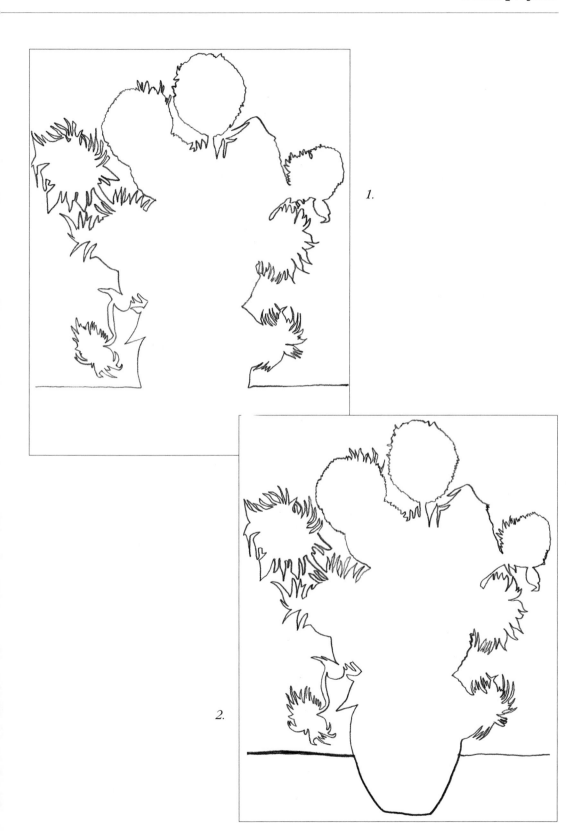

1.

2.

The next stage in the drawing as shown in example 3 is when you begin to draw in the smaller or secondary areas of negative space. These exist as small holes that appear through the objects that we are drawing. This part of the drawing completes the drawing of the negative space, and at this point we can now see how important this concept is as it holds the whole composition together in a spatial context. In other words the objects appear to be anchored in a real space, rather than floating in the picture plane

In the final drawing we have now filled in the rest of the visual story by defining the objects first, and then adding the tone and the texture (see tone and texture examples for further references). Now we have a complete work that pulls on a number of visual elements to make it work. There is also an example in the charcoal section that illustrates how a negative space drawing can be constructed.

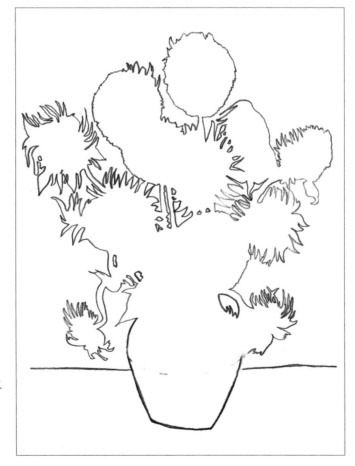

3.

Final drawing

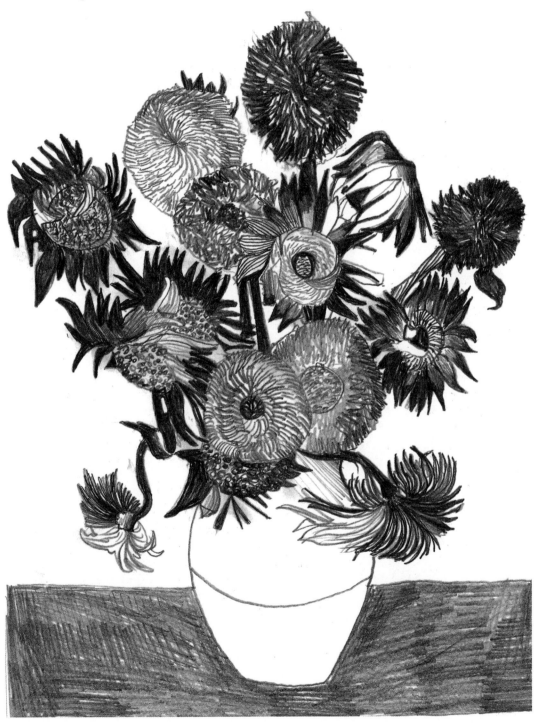

SHAPE INTO FORM

Shape can very easily be transformed into form by the use of shading. We can see in the drawing after Picasso (opposite, below) that regular shapes have been given the illusion of three dimensions by using various well-known shading techniques. He has taken these shapes and turned them into representations of human forms. Not only has he given them form, he has given them a character, and a life. He has created the form by using different types of bracelet, crosshatch, and linear lines to build up tone. All these processes are consistent in that they follow the planes of the form You will see from the examples that some systems of shading suit different types of forms.

An example of shape using tone after Morandi.

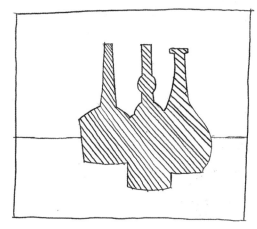

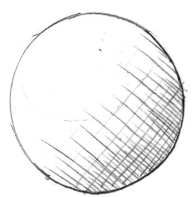

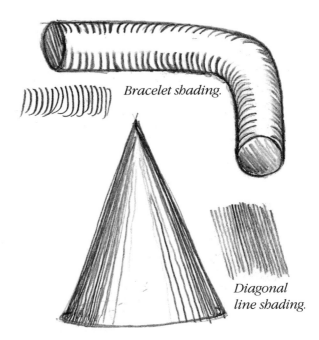

Bracelet shading.

Sphere using crosshatch shading.

*Diagonal
line shading.*

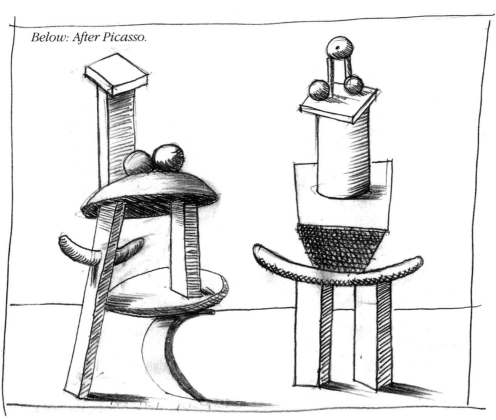

Below: After Picasso.

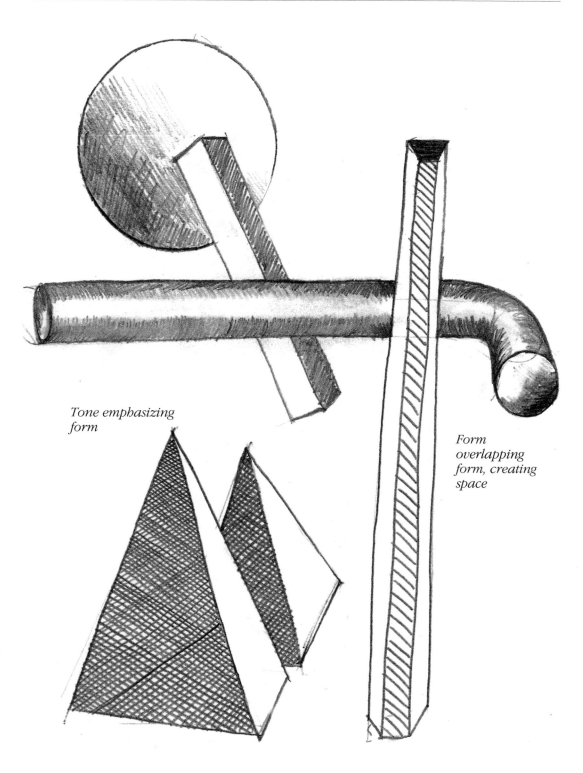

Tone emphasizing form

Form overlapping form, creating space

Here we see different shading techniques and how they can bring forms to life. Note that although different methods have been used, all follow the plane or surface of the form.

47

PLAYING WITH COMPOSITION: ORGANIC SHAPES

Medium: 2B pencil

In this example (after Joan Miro) the composition is based on a more organic flow of shapes. Part of its impact is created by the inference of textures. All the elements we found in the previous example are evident here, too, although in this instance the nature of the shapes implies other considerations. This drawing seems to have a life, and we have a sense that it is still growing. There's a mood, an almost dream-like quality.

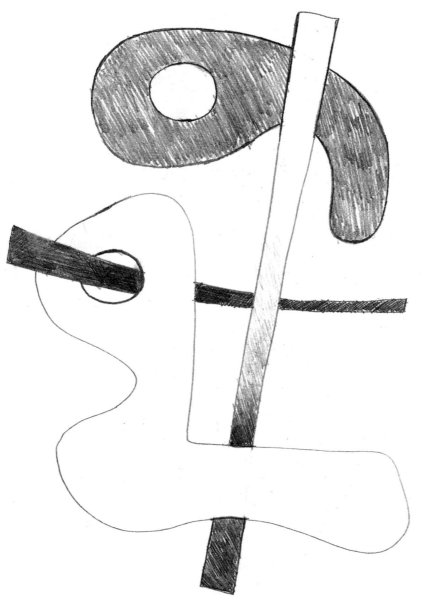

Line creates organic shape.

Shape overlapping shape creates space.

Shapes creating a transparent overlap.

Textured overlapping shapes creating space.

STEP BY STEP DRAWING OF A HEAD

The illusion of volume is central to the success of the following portrait, which I built up in a series of six drawings. I used a 2B pencil and cartridge paper, but almost any pencil would do, as would any type of paper. You might like to practise drawing ellipses, cylinders, eggs or ovoids before starting.

METHOD

1/ Draw the shape of an egg/ovoid. Try to do this with a free, expansive movement, sensing the shape rather than using your eye to gauge it precisely. Repeat the shape several times, drawing over your original lines, as I have done here. Now draw an ellipse, as shown, to give the shape the appearance of form.

2/ Create the basic form of the neck by adding a cylinder to the bottom of the egg form.

3/ Draw in outline the back of the head. Now extend the ellipse to meet these lines, giving the form of the skull. The lines of the ellipse are called cross-sectional analysis lines. They enable you to have a full visual understanding of the form and a sense of the back, front and sides of the head you are creating. These lines also provide the illusion of volume.

4/ Now we begin to build the face. Draw two parallel lines at a slight angle from the centre plane of the forehead. This appears as a wedge protruding out of the front plane of

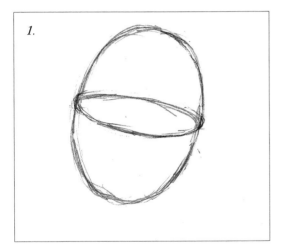

1.

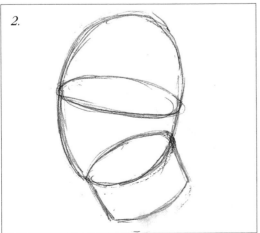

2.

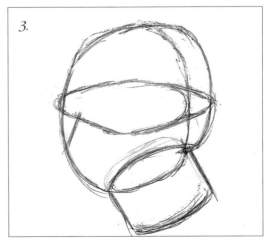

3.

the face, and is the basis of the nose. At the bottom of these two parallel lines, draw a line between them and which then extends back in space following the front plane or angle of the face. Now draw a line tilting back in space and following the side plane or angle of the head. Join up this triangle by drawing a straight line down the front of the face. From both corners of the front plane of the forehead draw two downward lines to just below the bottom of the original egg shape. Make these two lines slightly narrower at the

bottom to give a sense of form to the front of the face. Join these two lines at the bottom with a straight line that follows the angle of the front plane of the face and then follows the angle of the side of the head through to the back of the original egg. If you look at the drawing, you'll see that you are repeating the lines used to establish the nose, only on a bigger scale. We now have the underlying form of the chin and jawbone.

5/ Add spheres to denote the eye sockets. One sphere lies in front of the nose, the other directly behind it. Now we have the underlying volume of the eyes.

6/ In the preceding five stages we have built an overall sense of the volume that makes up the head. Once this is established it is your base over which you can draw in the characteristics of the particular person who is sitting for you. It's important to allow this under-drawing to remain, because it will reinforce the illusion of form and guide your over-drawing.

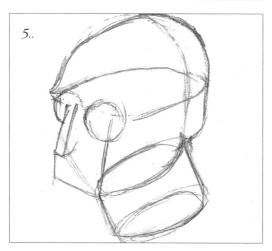

4.

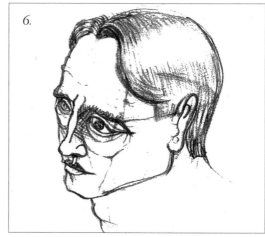

5..

6.

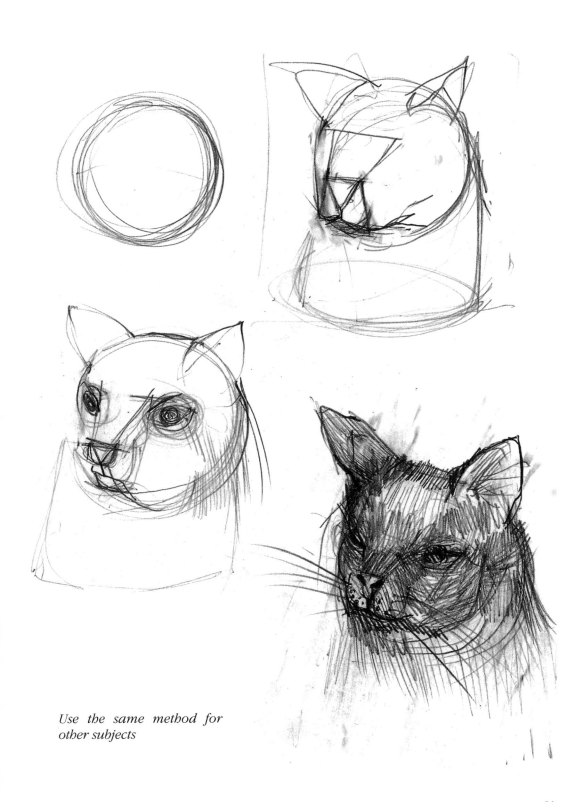

Use the same method for other subjects

CREATING ORGANIC FORM

MEDIUM: HB - 2B

Like the copy of the Picasso, the drawing based on a sculpture by Henry Moore, is directly related to the form of a figure. There the similarity ends. The Picasso copy has been made up to represent the human character and form, whereas the Moore is based on observations direct from a figure.

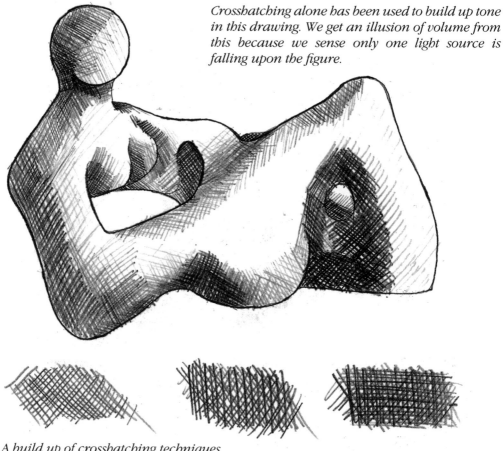

Crosshatching alone has been used to build up tone in this drawing. We get an illusion of volume from this because we sense only one light source is falling upon the figure.

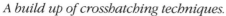

A build up of crosshatching techniques.

Using crosshatching to build form.

CREATING FORM USING TONE

Medium: 3B
The tone used here relies on an observed directional light source, which is then exaggerated to create the effect. The shadow cast makes us believe the sphere has form. Without it the drawing would look flat.

Medium: 4B
This cube has been constructed using three defined tonal variations - white, grey and black – to give the illusion of form. It is a constructed illusion, of course, and has not come about as a result of observed tonal changes.

Medium: 5B
The lighting appears to be from the front in this example of constructed tonal form. The light cast at this angle is very intense, gradually fading to complete darkness towards the sides of the cone. Lighting was used by early Renaissance artists such as Giotto.

Medium: 6B
The cylinder is like the sphere in observation, tone and how light plays across the surface of the form. But the tone we have used to define the form is an expressive gestural tone. It has less form than the previous tonal gradation and is more emotive and responsive to the observation.

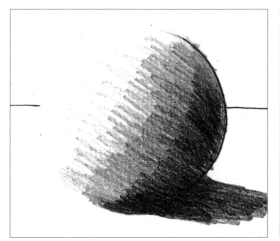

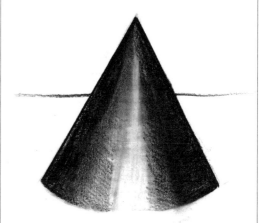

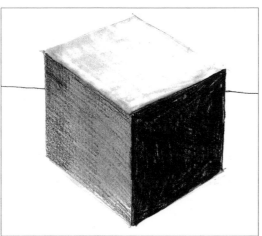

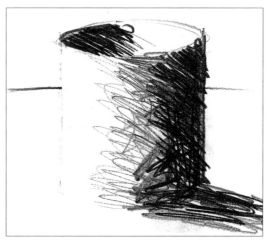

PROJECTION SYSTEMS AND THEORETICAL DRAWINGS

Theoretical drawing systems include orthographic drawings, planometric drawings, isometric or parallel drawing systems, trimetric, and perspective.

These drawing systems are very useful particularly for architects and designers. They are usually used as presentation drawings for clients. The orthographic or the planometric system of drawing is probably the easiest to understand as this is just a flat representation of an object, usually from the front and is done to a scale. See the example on page 55 of a pair of scissors, and pliers. Sometimes in these drawings, you will have tonal keys to give you the idea of plane recession, and form. The easiest way to go about producing one of these drawings is to place an object like a pair of scissors down on to a piece of paper and then draw around them. What you will have produced in this drawing is an outline of the object and that is what an orthographic projection is. To complete the drawing, observe, and draw in the rest of the detail of the object and then code it tonally or texturally accordingly.

ORTHOGRAPHIC OR ELEVATION PLAN

Orthographic drawings represent the object being drawn or designed as flat. They can represent the design as linked individual drawings from all sides. This is usually referred to as plan, front and side elevations.

They can best be described as representing a silhouette of an object on the picture plane from one side or the other of the plan. They show one face of the object and from that face the other faces can be planned and plotted. This is technically referred to as the first angle projection. First introduced by a French military engineer, Monge, at the beginning of the 18th century, it was very quickly adopted.

Orthographic drawings represent the object being drawn, or the face of, and from that face the other faces can be planned and plotted.

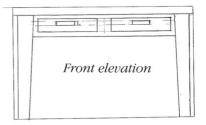

Front elevation

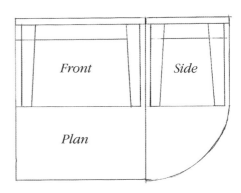

Front *Side*

Plan

A table, showing front, side and plan elevations.

The shape of an object from the front can be understood by placing it in a box or rectangle that relates to its proportions.

EXERCISES

SHAPE AS A PLANOMETRIC PROJECTION

In this exercise tonal keys are used to give an understanding of planal recession and form.

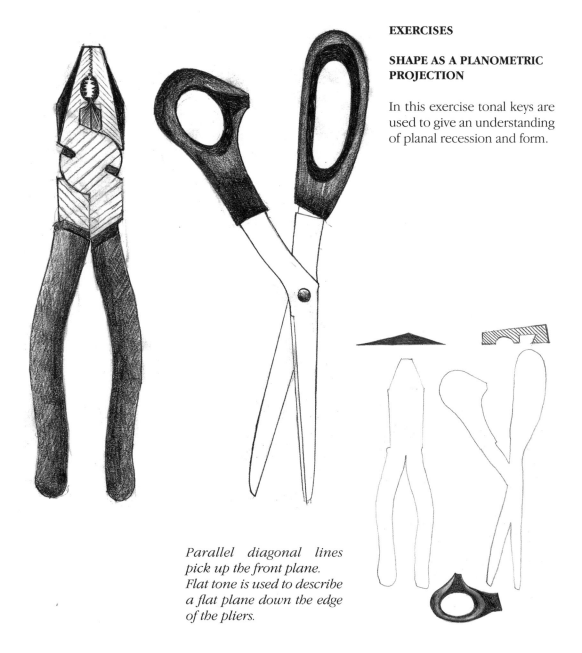

Parallel diagonal lines pick up the front plane. Flat tone is used to describe a flat plane down the edge of the pliers.

ISOMETRIC OR PARALLEL PROJECTIONS

To help engineers, architects and designers give a fuller three-dimensional under-standing and impression of their ideas and finished works, other methods of drawing were developed from orthographic pro-jection. First came the isometric projection process, introduced by an English con-temporary of Monge, Sir William Farish, which enabled all the faces of the front, side and plan to be joined together.

Using a specific angle from the 90 degrees angle creates these drawing systems. For instance, an isometric projection is always conceived by using an angle of 30 degrees as shown in the systematic series of examples on page 57. You can see in this example we have created a chair by creating it in an Isometric projection. There is also a simple example of an isometric projection shown on the right. In this example, you can see how a block has been cut had a segment removed. One can quite clearly see that all the angles for this drawing are based on 30 degrees of a 90 degrees angle. Drawings based on this system were used in the aircraft industry to assemble aircraft, and they are used by interior and theatre designers as finished working drawings that the makers would work from.

1/ Create two ninety-degree angles.

2/ From those ninety angles create two thirty degree angles.

3/ Using the same vertical create another two ninety degree angles.

4/ Now create two more thirty-degree angles, and then place two between these angles to create what appears to be the side edges of a rectangular box.

5/ At the two top corners of this rectangle create two more ninety-degree angles, and from those two angles create two thirty degree angles that will converge and meet creating the top of the rectangle.

6/ One can now fill in the back of the box consistently using a thirty degree angle as seen with the dotted lines in this example. One can also now use this rectangle or crate to plot an object within this projection system.

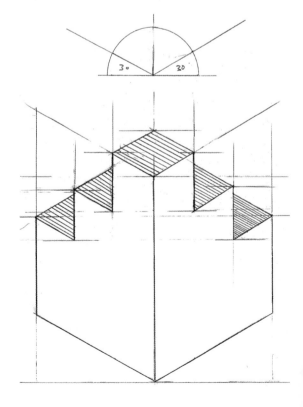

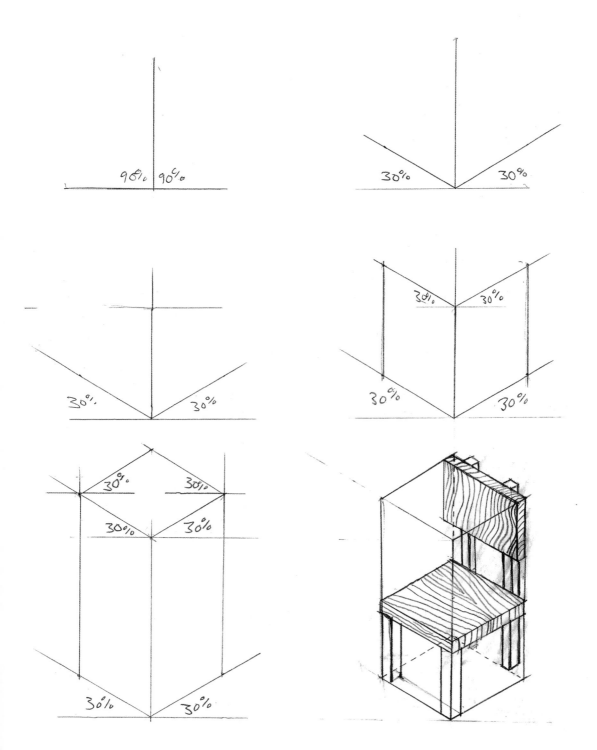

TRIMETRIC PROJECTIONS

Trimetric projections are very similar to isometric projections and are used for similar reasons. The difference being that the trimetric projection can present different orientations of a box or object on the same picture plane. Therefore, what we have are different degrees of orientation. This type of drawing is very useful as a diagrammatic drawing that is used to help you assemble or even take apart a piece of furniture or machinery. One usually sees these types of drawings in car manuals.

THE TRIMETRIC SYSTEM IN USE

Industrial designers use the trimetric system to 'crate' a form; that is, to put it in a box. The shape of the object is drawn on the front face of the box and then the form of the shape is projected back into the 'crate'. By encasing volume and form in this way, designers can visualise how their ideas will appear in reality.

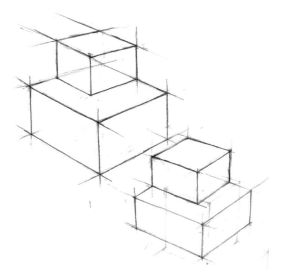

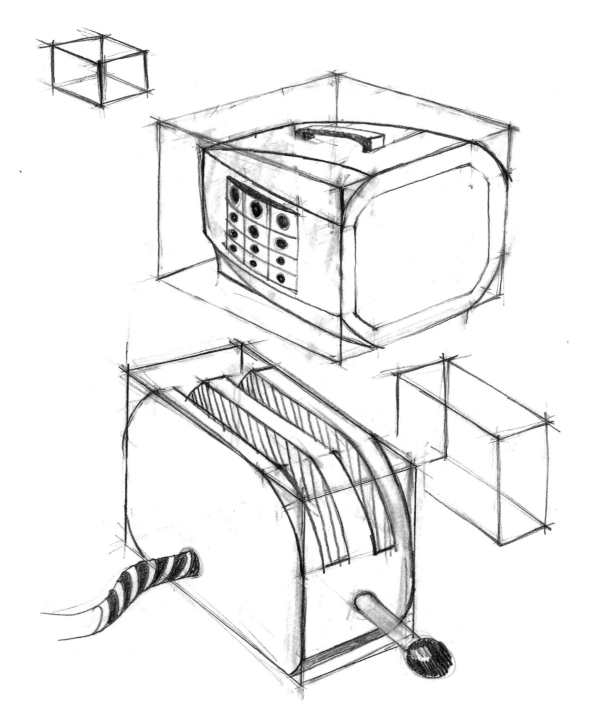

PLANOMETRIC PROJECTIONS

First introduced by Auguste Choisy at the end of the 19th century, and the favoured system of Le Corbusier and Theo van Doesburg, these projections were primarily produced for architects. This type of presentation gives a truer, three-dimensional illusory understanding of the space and form of a building produced from a plan in scale, and has become very popular among architects.

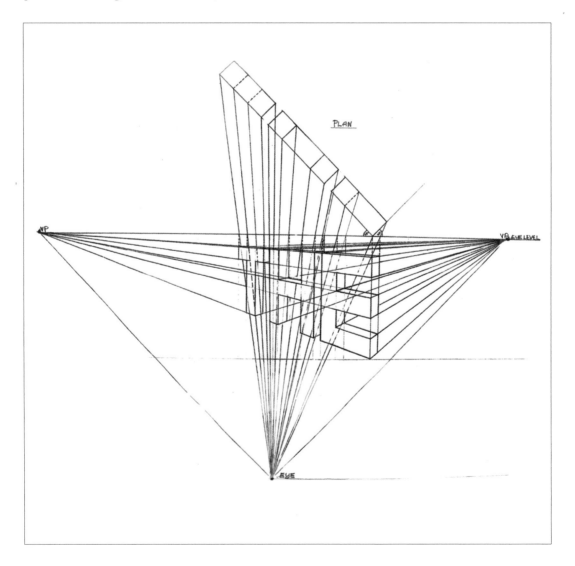

CONVERGING PROJECTION SYSTEMS OR PERSPECTIVE

Perspective is vital with any technical drawing. Perspective establishes a viewer's cone of vision and a context for objects contained within it. For example, a representation constructed on a picture plane has an established ground and horizon upon which objects can be placed in relation to it. Perspective is distinct from the other drawing systems we have been looking at in that it creates an illusory yet real impression of space which employs an imaginary or observed view created purely through our observation of a subject. These two systems employ the same rules, although they arise from different creative roots and needs. The constructed perspective drawing is dominated by pure theory; the observed perspective drawing is from one view point. Perspective is a system of drawing that shows the illusion of three-dimensional objects in a picture space. To produce a good perspective drawing one has to abide by a certain set of rules. To break these rules is to undo the illusion.

There are two common uses for perspective. One is a perspective drawing constructed from our imagination and creative thoughts; the other is constructed from an understanding of planal recession and form.

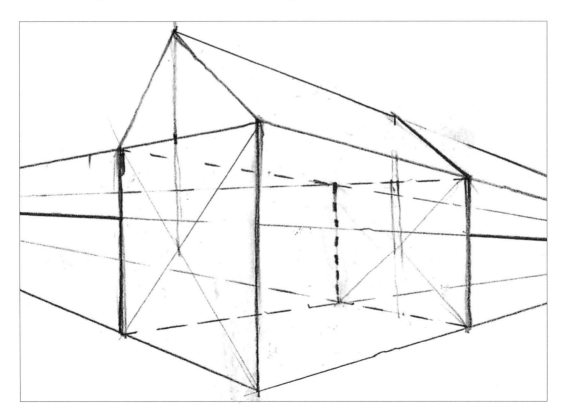

ONE-POINT PERSPECTIVE

These are the basic rules that govern a one-point perspective drawing, and it is worth remembering that all lines that do not appertain to the horizontal or the vertical axis will go back to or terminate at the perspectival point that as been set up in this drawing.

1/ Draw a square on your piece of paper just to the left or the right of the centre of your piece of paper. Make sure that this square runs parallel to the edges of the paper.

2/ Now draw a horizontal line across the piece of paper that travels through the square. This will be referred to as the horizon line, and in drawings from observation it can be referred to as your eye level.

3/ Put a dot on the horizon line that sits on the other side of the paper to the square you have just drawn. This is now known as the vanishing point.

4/ From the nearest top and bottom side of the square draw two straight lines that converge to the vanishing point. It is important that extreme accuracy be observed in drawings of this type, as any slight mistakes can lead to distortion in the drawings. Therefore, I would advise that beginners use a ruler for this part of the operation.

Now do the same from the top and bottom of the far end of the square. You will now have a drawing that resembles the example at the bottom of the page.

5/ The next step is to place the back end of the box in. Do this by drawing in a vertical between the set of converging lines that we established in step 4. You need to place the line purely visually to make the illusion of the box. Place the line too far away and you produce an oblong lying down, and place the line to close and you produce an oblong

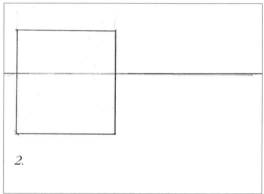

1.

2.

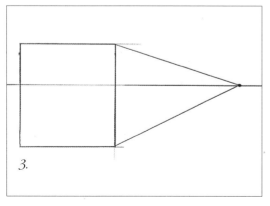

3.

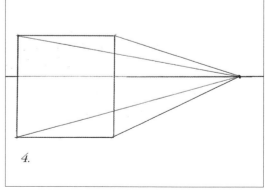

4.

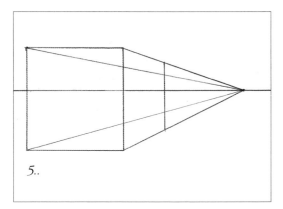

5..

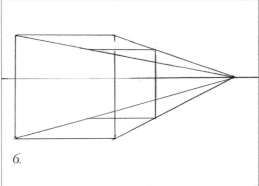

6.

standing up. So try to place the line so it makes the illusion of a cube.

6/ Now draw two horizontal lines from the top and the bottom of this vertical line that you have established as the back of the box so as they join up with the two converging lines that run from the other side of the box to the vanishing point.

7/ Now draw your final vertical line to establish the complete box in a one-point perspective.

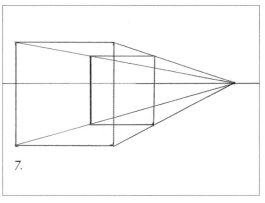

7.

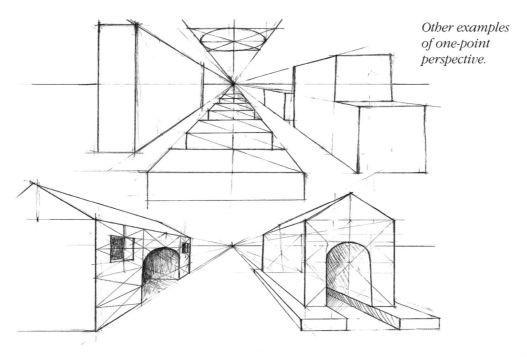

*Other examples
of one-point
perspective.*

TWO-POINT PERSPECTIVE

1/ In two-point perspective the drawing theory is very much the same. The difference is that the box or cube is set in a different orientation to the picture plane – instead of drawing a square in a facing position or running parallel to the picture plane, as we did in step one for the one point perspective drawing. We instead draw a vertical line just to the left or right of centre.

2/ Now put in the horizon line that, for the sake of this example, makes this line cut through the vertical line just above half way, and it should travel from one end of the paper to the other. For other practice examples, you can be diverse as to where you put the horizon line to experience the dynamics of perspective space.

3/ Place two vanishing points on this line one at one edge of the paper and the other at the other edge of the paper.

4/ As with step four of the one point perspective now draw a line from the top and the bottom of the vertical to the vanishing points on both sides. Again accuracy is paramount in this type of drawing.

5/ You need now to visually place the back ends of the box in. Do this by placing a vertical line on one side of the original vertical so as it fits between the converging

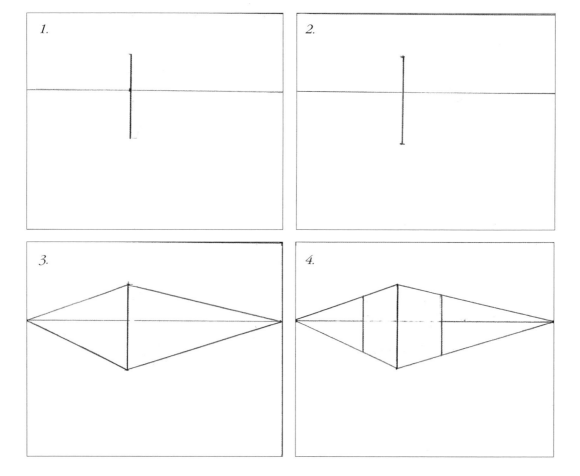

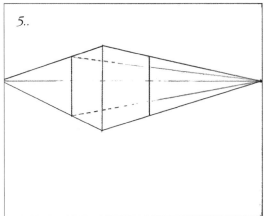

5..

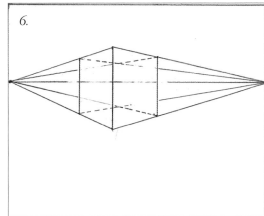

6.

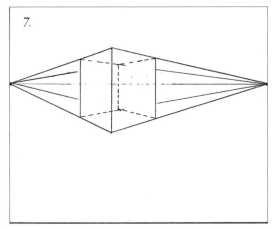

7.

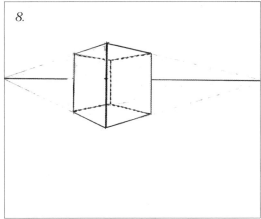

8.

lines and it gives the appearance of being box shaped. Then repeat the process on the other side of the original vertical. You will now have created a box in a twisted orientation using two-point perspective.

6/ As with the one-point perspective we need to create the illusion of the back of the box. To do this draw two lines from the far left hand vertical to the vanishing point on the right-hand side this is shown as a dotted line in the example.

7/ Now do the same from the vertical line on the right hand side. Draw two lines from the top and bottom of this vertical that will extend back to the vanishing point on the left hand side.

8/ Finally, to finish off this drawing, all you need to do is to draw a vertical line between the two points at which they cross at the back of the box.

It is possible, using the same process but changing the vanishing points, to create many boxes in different orientations on the same picture. This process described here has also been used in the observed perspective drawing, but the vanishing points and horizon line or eye level is found through calculation from our observation.

OBSERVED PERSPECTIVE

When drawing perspective from observation you must be able to accurately measure the angles. To start the drawing first establish your composition through your window mount. Once you are happy with your position, establish the first major vertical in the composition. From this we can establish the horizon line or your eye level. It is important that you keep this view constant while you are engaged in the drawing, otherwise you will experience distortion.

1/ Start your drawing by assessing where you think your primary vertical is situated. Establish it first, as you will be making your major perspectival assessments from it. In the first example you can see that the corner of the building in the row of houses is our main point of departure. So draw the vertical in position accurately first. In our drawing, we have now established where the corner of the house is and its height.

2/ From that corner we can now begin to construct the perspective structure, and establish our eye level in the drawing. To do this we need to begin to assess the angles from the top and the bottom of the verticals. We can do this as we did for the posture lines, holding the pencil on the angle of the building and then transporting this angle to both the top and bottom of the vertical line. If you find this process particularly difficult, you can use a

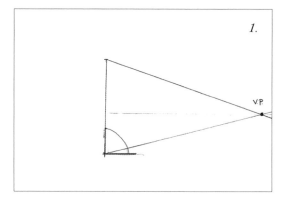

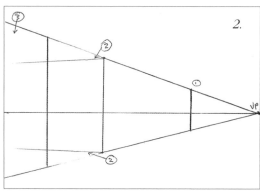

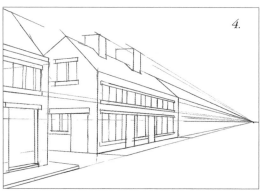

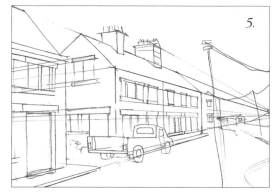

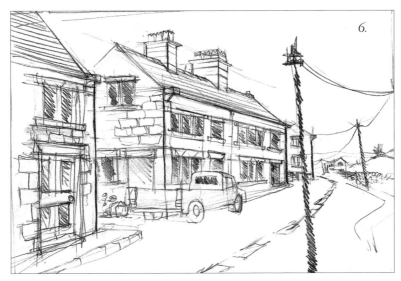

6.

form of geometry to establish the angles. As with the example of the isometric drawing, I have established the 30° angle from using a 90° right angle. You can place a right angle to the vertical and then make an approximation as to the angle of your observation. When you feel confident that the angles of the lines you are about to draw are right, use a ruler to draw them to the point where they converge. At this point you will have established for that building or object one of its vanishing points. It is on this point also that the horizon line, or the eye level, is established. Now you can draw in the eye level line by simply making a horizontal line across your paper. There is a simple rule to remember for perspective. All the perspective lines that are above eye level will converge downward to a particular vanishing point on the horizon line. The same is true for those perspective lines that lie below the eye level, only they will converge upwards to the horizon line to a particular vanishing point. The accuracy of these measured angles is vital to the success of the drawing. Once you have the two converging lines from your first vertical, you can use them as guides to draw the rest of the building.

3/ Decide how long the front face of the building is by looking back at the composition through the window mount. Put in a vertical line to denote the end of the building. This will

fit exactly between the two converging lines to give us the correct perspective. One can now do the same to the other side of the building, using the same process. However, you will notice that the perspective point on this occasion goes off the other side of the picture. Do not worry about this – it happens in most perspective drawings. In this detail we have extended the drawing perspectivally forward to draw the row of houses in the foreground. This has been achieved by extending the perspective lines that come from the vanishing point on the horizon line, and then placing the vertical line in to denote the edge of the building.

4/ Add the roof and the chimney pots so the building now has its basic structure.

5/ Architectural information such as doors, windows and pavements are now put in.

6/ We have now established the perspectival basis of the composition. At this stage your drawing will lack expression or character. In this final stage we need to put in the elements that make the drawing more real, such as the van, the telegraph poles, the curving side of the road, and the other houses in the background. Finally, it all needs to be brought to life by working over the top of the perspective with free, gestural lines.

Observed perspective

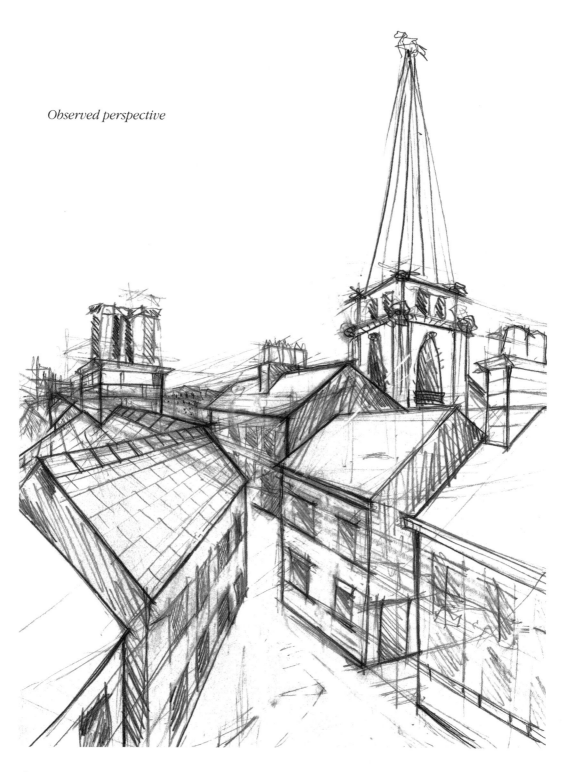

FANTASY ARCHITECTURE

Once you have gained a good knowledge of perspective you can emulate some of the great artists such as Perineasea who developed an amazing amount of fantasy architectural drawings. One can construct drawings that will lead the eye through a well-organised perspective or architectural space both for interiors or exteriors. It's a great way of flexing the imagination, and its fun.

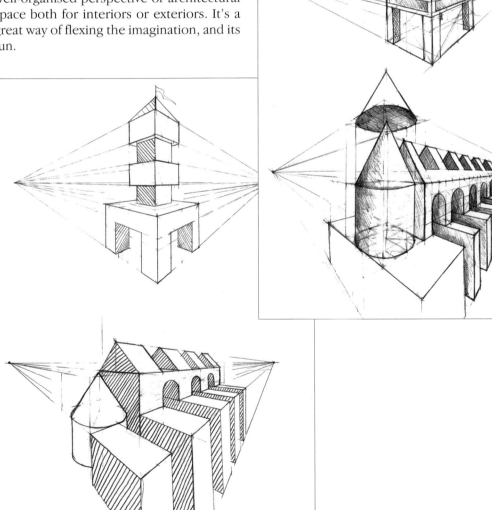

LIGHT AND DARK

SOFT PENCILS

Our first concern in this series of drawings is to create the fundamental form of the head, neck and shoulders if the light is coming from a fixed position on one side of the figure. In our example the light is coming from a fixed position on the left side. Once the fundamental form is established, you can concentrate on modelling the form through observation of how the shadows are cast and how they fall over the form. The figure here has the appearance of being constructed out of pure light.

TONAL DRAWING USING GRAPHITE OR VERY SOFT PENCIL

This is a tonal portrait drawing based in observation and it is done using a very soft pencil - 8b.

The first concerns of this drawing are to create a sense of the fundamental form by observing the nature of the effects of light. You will notice there is a very strong direct light that plays over the surface of the subject.

Step1/ establish the basic form of the head by drawing an ovoid or an egg shape. Draw two lines for the neck, and then two arced lines for the shoulders. This will give you the basic outline for the form of the head. You can now initially place the basic areas of shadow in on one side of the head leaving the other side in the light. But you need to put some shadow on the outside of the head so as to pick up the edge of the form on the light side of the face. Notice the free sketched way in which the tone has been placed down at this point in the drawing.

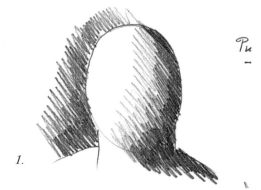

1.

The light source picks out the fundamental form of the portrait.

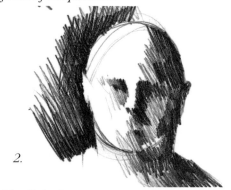

2.

The light becomes more distinct on how it plays across the surface of the form.

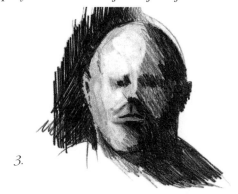

3.

More tonal detail that brings out the character and more personal details

Step 2/ now look at the person you are drawing and begin to pick out the other major areas of tone that exist on the head. It is a mistake in this type of drawing to try and render features as this is a drawing that will bring you the likeness through the tonal rendition of the drawing.

Step 3/ one can now begin to put the more detailed and subtler tones that in turn will start to imply the idea of a likeness of the subject.

Step 4/ in this part of this final piece of the drawing I have used an eraser to bring back certain touches of light, just to enhance the atmospheric effect of the light.

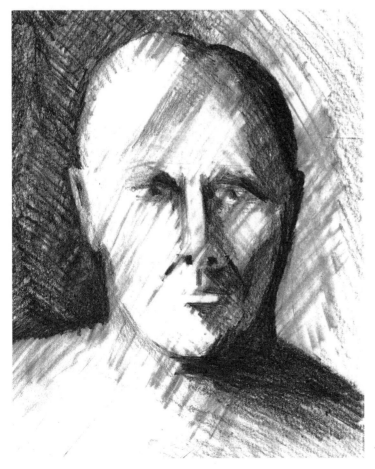

What is so dramatic about this drawing is that it is purely based in the observation of a light and dark effect that is known as Chiaroscuro.

Using a rubber in a directional motion gives an effect of shimmering light.

4.

LINEAR AND TONAL DRAWING USING GRAPHITE AND PLASTIC ERASER

This is a line and tone drawing of the female nude, but it is a very different in concept to the last drawing. Whereas the last drawing was based in the analytical observation of light and how it falls on the form, this drawing is more of an expressive metaphor of the reality we are seeing.

1/ In stage one of the examples we are drawing with a continuous line. That line is made by not taking your graphite off the paper until that section of the drawing is finished. This line is trying to establish the idea of form by following the contours of the form just as if you were actually drawing over the body itself and leaving a trace. You can also see from the illustration that the line is a free-roving type of line and it doesn't follow any predictable track.

2/ Gestural tone is now placed over the linear drawing. This tonal application is based in observation so the model should be illuminated from a particular direction to give a definite sense of light and dark over the subject. The tone is applied in a quick gestured manner so as not to leave too much time to dwell on the consequences of the action. A gestured drawing is a drawing that is based in a response to what you are drawing rather than a calculated observation.

3/ This stage may seem odd, as what we are about to do is to use an eraser to work over the whole drawing to take it back. Use the eraser in a diagonal direction and work it over all the drawing. This has the effect of

bringing an atmospheric feel to the work and it sends the drawing back into the surface of the paper.

4/ We can now begin to re-establish some of the tone and the line over the last section.. This gives the drawing a sense of atmosphere, drama, space and above all an expressive nature that holds the drawing together very cleverly as an expressive metaphor. There are examples of artists who work like this when drawing, artists like Aubach, Giacometti, and Rembrandt.

1.

2.

3.

4.

GESTURAL DRAWING WITH GRAPHITE

The next example is a line and tone drawing which derives much of its impact from knocking back with an eraser, a method that is particularly appropriate for figurative portrait work; you will find examples of its use in the drawings of Auerbach and Giacometti. You may find it a bit strange at first to reach a certain point and then have to rub out what you have just done, but after spending time practising with the technique you will begin to see what can be achieved with it.

1/ Establish the form using a continuous line (i.e. not taking the graphite from the paper while you draw) and following the shape of the figure. Imagine you are actually drawing your line on the person.

2/ Place gestural tone over the line. Gauge the strength and extra dimension it can bring to your drawing.

3/ Using the eraser in a diagonal direction, go over the drawing and rub out what you have just done. This will set the portrait back into the picture plane and also give it atmosphere.

4/ You can now re-establish the tone and some of the line, imparting to it a sense of drama, space and expression which will hold the drawing together.

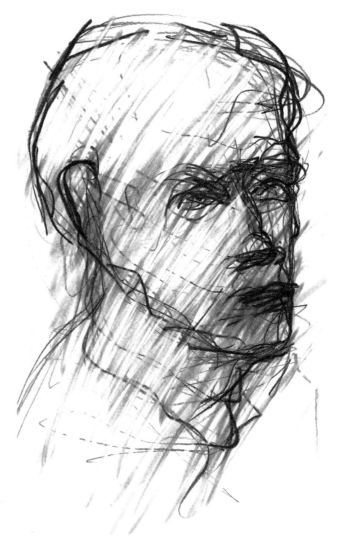

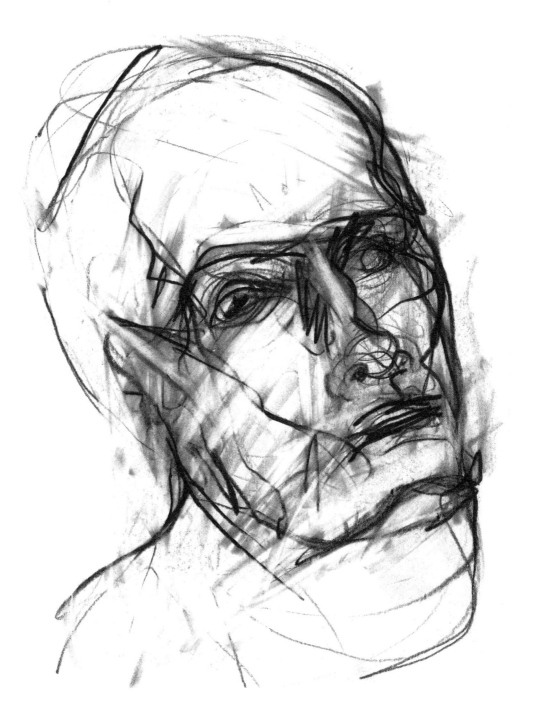

CONSTRUCTED TONE LANDSCAPE AFTER CEZANNE

As well as using tone from observation to construct form or express an emotion we can also use a constructed form of tone to create the illusion of space. In this drawing after Cezanne the tonal drawing is a very formal one and is not very reliant upon observation. Although the basic composition comes from observation, the tone in the drawing is a means to an end, and informs us of a planal recession instead of the idea of volume. Cezanne in this picture seems to go out of his way to deny perspective and instead he emphasises the horizontal and the vertical axis in the drawing.

He also uses a type of shading that

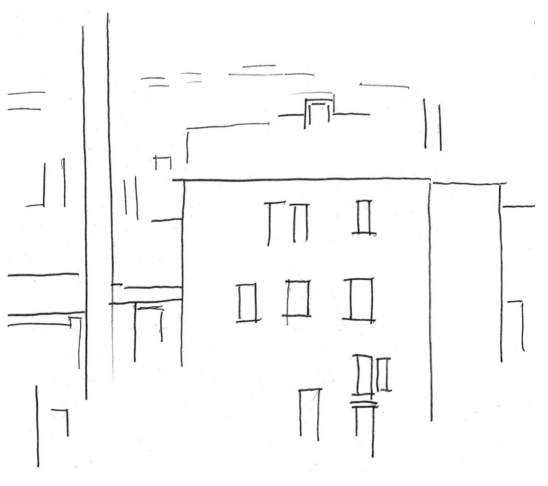

functions on the edges of planes giving them a sense of planal placement in the picture. He builds up the composition in a well orchestrated fashion that has a classical sense of balance and harmony to it.

The shading technique used in this drawing is focused on the inside and the outside edge of the objects in the composition. To create a recession you darken the edge you want to recede. To make a plane edge come forward against its neighbouring edge you make it lighter.

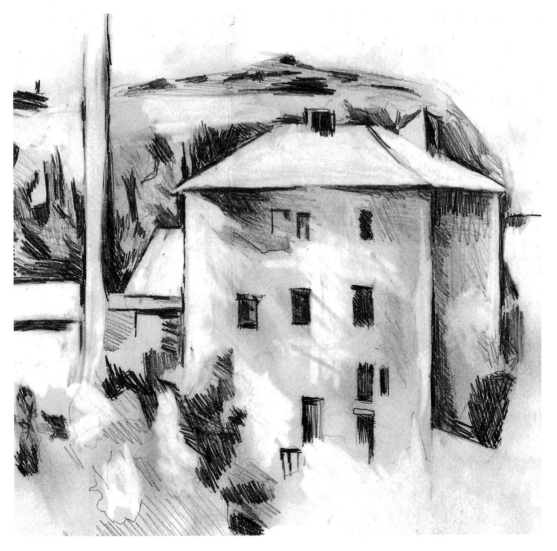

GRAPHITE LANDSCAPE DRAWING

This drawing is very similar to the drawing using continuous line and tone to form the model. Only it is a landscape sketch that is produced here in almost exactly the same way as the life drawing, using the same medium and the same methods. However, this is a sketch and a sketch is different to a drawing. A drawing is something that stands

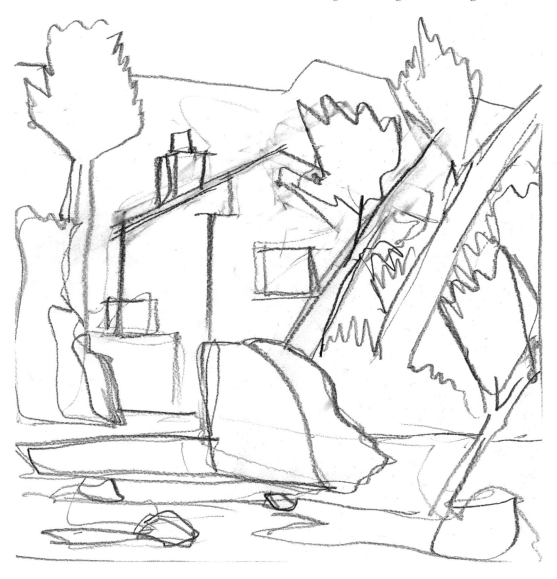

as a work of art in its own right whereas a sketch is meant as a piece of information for the artist to refer to at a later date as a piece of research. You should not undervalue the intrinsic qualities that sketches and doodles have.

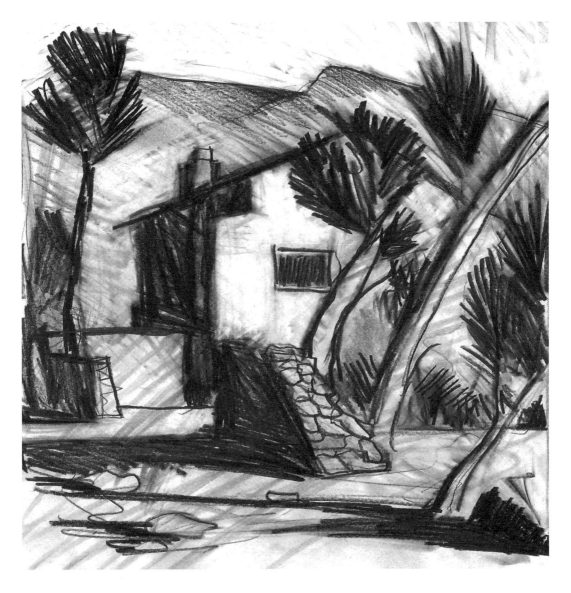

CHARCOAL

Charcoal, Conte Crayons and Compressed Charcoal.

The main feature of these mediums is that they make very strong drawings in a linear, tonal, textural and atmospheric way, and the drawings nearly always tend to be very dramatic and expressive.

CHARCOAL

Charcoal is the oldest medium of the three materials in this section. It is made from wood that has been slowly charred in a controlled firing. The material takes on the natural form of the wood that can range from a twig to something as large as a branch. The largest piece of charcoal I have seen is up to 2 inches thick and this is called scene painters charcoal.

Charcoal is a material that has been around since the dawn of man. As man discovered fire then he discovered charcoal, inadvertently at first then by purposeful production. The inadvertent discovery of charcoal enabled man to make his first drawings, recording his observations and thoughts of life in his surroundings. The mark that charcoal made would soon develop into a sophisticated visual language that would be an expression of the day-to-day lives of these early peoples as seen today on cave walls.

Since these early discoveries, man has developed the medium into other forms such as conte crayon, wax crayon, and a form of compressed charcoal. We have developed

stabilisers to fix the drawings and make them permanent. We have also developed the use of erasers that remove or enhance the potential of the drawing.

Charcoal has qualities that are obviously different to other materials. Compared to graphite or pencil charcoal is a soft smudgy material that delicately survives on the surface of the paper until fixed and made permanent. The material produces a good strong line, tone, and textured surfaces in a similar way to graphite but with a character that is very different. Charcoal has what I can only describe as an ethereal, atmospheric quality to it. It feels more direct as a material when one is using it. It feels softer and gentler in its response, whereas graphite has a more immediate harshness to it.

Another material made from charcoal is compressed charcoal. This is a material that first came into existence in the first half of the last century, and behaves more like a pastel in that it holds the surface of the paper more substantially than charcoal, and has a propensity to be slightly denser than charcoal. Compressed charcoal is made by crushing charcoal into a fine powder then mixing it by rolling it with a fine binder to make a compressed charcoal stick. The stick has to be made to such a consistency so that it can be handled without crumbling or breaking, yet at the same time soft enough to make a mark when put to paper. Varying degrees of hardness and softness can be

obtained for compressed charcoal as with pencils. The product is manufactured and can be brought from any art suppliers.

Finally, one can obtain charcoal in a pencil form. This enables the charcoal to be sharpened and allows it to be used more like a pencil. However, you do lose the intrinsic quality that charcoal has when used in this form.

CONTE CRAYON

Conte crayon is the same as compressed charcoal except that the pigment and the binders are different. Conte crayons are small square sticks that are made from pigment mixed with clay and a binder. They are harder than charcoal, compressed charcoal, and pastels. The traditional colours are black, white, sanguine, bistre, and sepia. You can however now get conte crayons in different colours. Conte crayon can also come encased in wood like a pencil. Conte crayon, like charcoal, can be smudged. However, it creates a very intense black tone that is much stronger and more difficult to remove than charcoal. Conte crayon is very good for both tonal drawings, and more intense mark-making drawings.

WAX CRAYONS

These are very different in character to the previous materials. They are made from a mixture of paraffin pigment and wax. They can come in many different colours and they have a very greasy feel to them just like wax. They are not at all dusty like charcoal so it is not easy to smudge the material. If you need to erase the material on the paper you need to use a solvent and when this is applied it will smear and loosen the wax on the paper. However, it is a very useful material for building up layers of different colours, dark over light, and then scratching back through these layers revealing the colours from underneath. This technique is call scraphite, and the artist Paul Klee used it very successfully. The special qualities that emerge from this technique are that the marks that one scratches into the surface appear very luminous. This way of working does not lend itself to being a very naturalistic means of recording our observations, but it is very good for rendering more symbolic and abstract statements.

SPANISH BLACK

There is a very quick and cheap way to make a poor man's charcoal that is known as Spanish Black. This charcoal is made from burning the end of a cork for a few minutes. I can remember using this as a student for very soft drawings when I could not afford proper charcoal. It is also very good as a cheap form of theatrical make up, and can be used for false beards and eyebrows.

FIXATIVE

Fixatives are used to preserve charcoal drawings. The fixative solution is applied with a sprayer or an atomiser. It should be applied to the drawing in fine coats to create the desired effect. Fixative is a binder that holds the loose particles of charcoal to the surface of the paper. The most common form of fixatives are diluted solutions of mastic, shellac, or manila copal diluted in alcohol. Nowadays, modern synthetic resins are used. Charcoal that has been previously dipped in linseed oil before use needs no fixing. However, you lose the soft atmospheric quality of the charcoal that is its main characteristic. It is essential to fix your charcoal drawing when you have finished it, otherwise it will remain unstable and liable to get damaged through smudging.

1.

FIXING YOUR CHARCOAL DRAWING

Charcoal is, as we have mentioned, a very unstable material. Once applied to the surface of the paper or support it can easily be erased or smudged, especially accidentally. When you are satisfied that your charcoal drawing has reached a point where you feel it is finished, it is important that you stabilise the drawing immediately on to the support. This is what is termed fixing the drawing.

Fixative is a solution that acts as a binder. It seals the charcoal or the pastel on to the support which is usually paper. If the drawing is not fixed it will remain unstable and thus liable to damage and disfigurement.

The fixative solution is applied by spraying the solution evenly over the drawing surface, using two or three coats very thinly and allowing it to dry between coats. This ensures that the whole surface of the drawing

2.

has been covered. The solution should dry clear so as not to have an effect on the drawing. But some home made solutions can yellow with time. It is best for longevity that you use a manufactured commercial solution. These fixatives can be brought at any art suppliers, and usually come in two different forms.

The first and easiest way to apply fixative is to buy the spray can version of the material (illustration 1). Although this can be expensive, in my opinion it is worth it. The other option is to buy the fixative in a bottle. It comes as a clear solution, and it needs to be applied through what is called a diffuser. One end of the diffuser is placed into the fixative solution and the other end into the mouth (illustration 2). You then proceed to blow steadily. This action creates a spray, which you aim at your drawing. You must repeat this action two or three times, as you would with the spray can variety of fixative, to achieve a good covering.

A much cheaper way to fix your drawing is to make your own fixative from diluted resin. This is a very time consuming process, but if you like doing this sort of thing it can be very rewarding. (If you are interested in attempting this, you can find 'recipes' in the 'Handbook of Artists Materials and Techniques' by Ralph Mayer.) You will need a diffuser as applicator if you opt to make your own solution.

ERASERS

Most erasers that are used for charcoal can also be used for graphite. However there are particular erasers that are more appropriate for charcoal mediums. A putty rubber is a very good example, as it seems to soak up the charcoal from the surface of the paper, and it can be kneaded into different shapes to erase in particular ways that enhance the drawing. There are other erasers that also work well with charcoal.

A length of cloth can be used to remove charcoal from the surface of the support. This is achieved by beating the cloth over the area you wish to remove. It will not however completely remove the charcoal surface, but it will leave the ghost of the drawing. This can be a useful as when you redraw it stops you making the same mistakes over again. One can also use bread to remove charcoal from the surface of the support, and also sandpaper. Compressed charcoal and conte crayon are much more stubborn marks to remove so my advice is to use a good quality plastic eraser. Marks or areas made by wax crayons can be removed by solvents or scratching at the surface with a razor blade. Removing wax crayon marks can be difficult.

SUPPORTS

Most charcoal, compressed charcoal, conte crayon, and wax crayon drawings are made on paper supports. It is important to experiment with different papers and surfaces, both flat and textured. Flat paper surfaces will allow an even line to be drawn and flat tonal surface to be created. Whereas a textured paper surface will give the impression of the texture of the paper.

Materials and examples of marks

WILLOW CHARCOAL

Willow charcoal or vine charcoal is a very fluid drawing medium and is much freer and more open in its application than pencil. It also lends itself to larger, broader drawing than the type of graphic drawings one associates with pencil. Examples of marks made by the willow charcoal are as follows.

1/ A diagonal line that moves from light to dark. Charcoal is very useful for making tonal changes very quickly.

2/ A tonal recession from light to dark that has been smoothed out by smudging the charcoal with the finger. Then lightly rubbed with an eraser.

3/ Here the side of the charcoal has been dragged across the surface of the paper to create a textural tonal gradation.

4/ Here we have a heavy strong line produced by placing a lot of pressure on the charcoal whilst making the line.

5/ Is the opposite of 4. This is a very fine line produced using very light pressure.

6/ Here we have a heavy dark thick line moving to a lighter thin line produced by changing the pressure whilst in the process of making the line.

7/ A tight cutting type of line produced by dragging the side of the charcoal across the paper.

8/ An open zigzagging line is produced in the same way as number 7, but this time one uses a pushing and pulling motion to create the line.

9/ Here we have a similar zigzagging line as number 8 - made in the same way but it's a more compressed zigzag.

1.

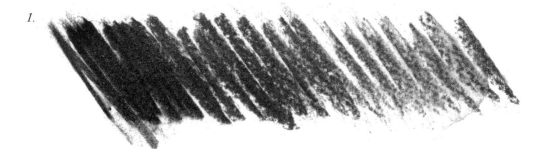

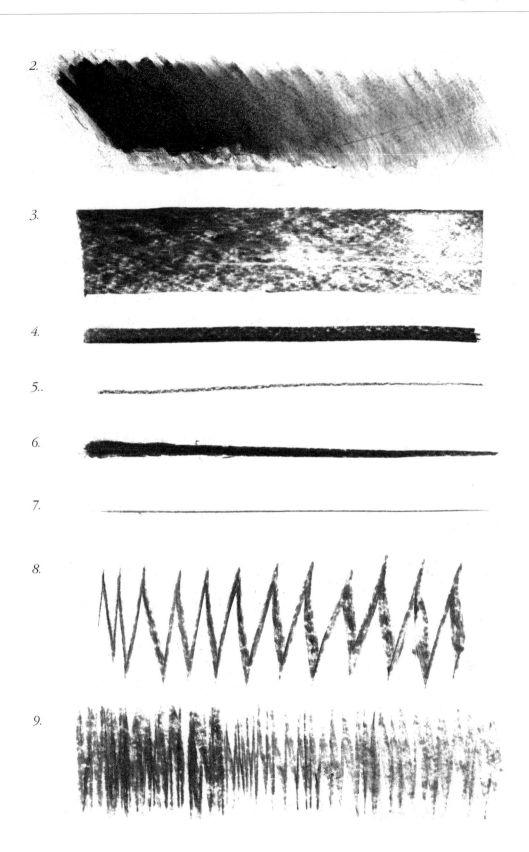

2.

3.

4.

5..

6.

7.

8.

9.

Controlled mark making with charcoal.

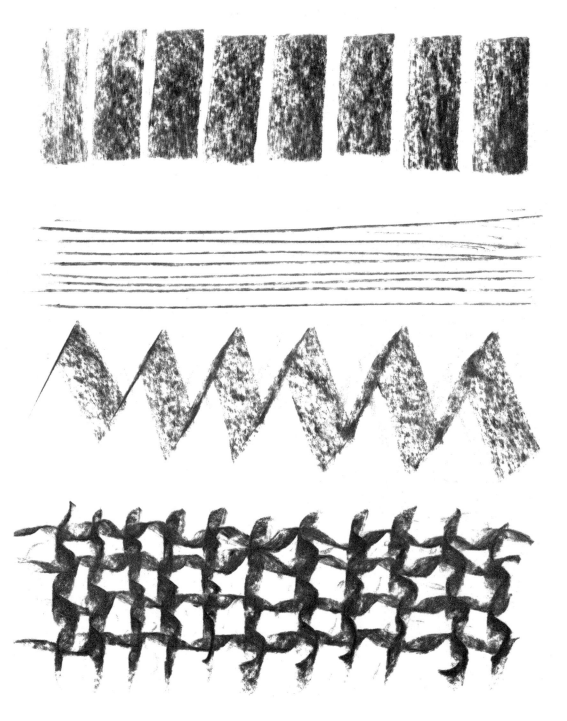

Expressive and fluid marks with charcoal.

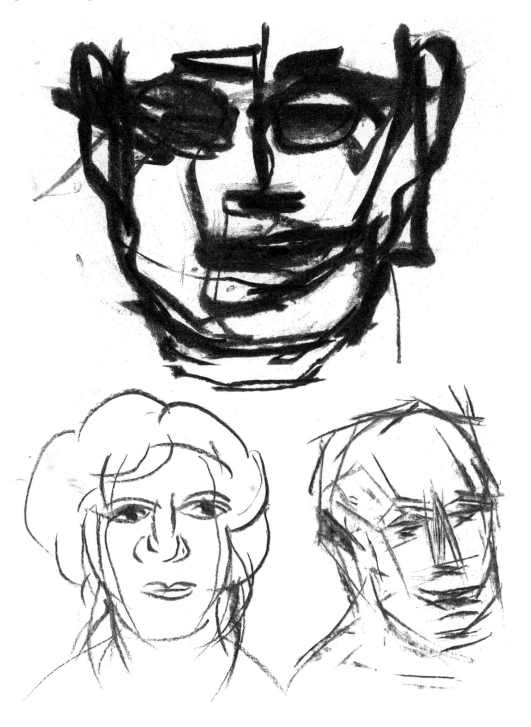

LINEAR SHADING TECHNIQUES USING WILLOW CHARCOAL

1 – 6 Show a series of techniques on how to build up crosshatching to create shading, and in turn, these techniques are used to create the illusion of form.

1/ Diagonal parallel lines created by using the side of the charcoal. See holding the charcoal.

2/ Diagonal lines in parallel directions. One set in one direction and the other set layered over the top going in the other direction.

3/ Vertical parallel lines.

4/ Vertical parallel lines over layered by horizontal parallel lines.

5/ Section 2 over-layered by section 3 shows a build up of tone.

6/ Section 2 over-layered with section 4 creates a much darker controlled tone.

7 – 8 this is called bracelet shading and is used to create the illusion of form.

7/ Bracelet shading to give the illusion of a sphere.

8/ Crosshatch bracelet shading - this type of shading was used by many artists such as Leonardo da Vinci and Michelangelo to draw the human from.

1.

2.

3.

4.

Keep practising these techniques – they are a vital component of many charcoal compositions.

5.

7.

6.

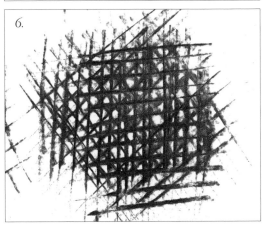

8.

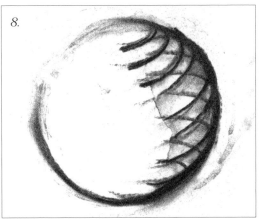

EXPERIMENTING WITH THE CHARCOAL MEDIUM

MAKING MARKS

As with the pencil, before you start to work with it in earnest you should become familiar with the medium and what potential it has. Charcoal is a very natural medium and therefore it does not lend itself to very tight diagrammatic work - it is too messy for that. It fundamentally lends itself to a more fine art and expressive notion of drawing. So it is a more open and expansive type of material to use.

The type of charcoal marks that are made in this section tend to imply texture and surface and therefore can be used in drawings that have a textural quality to them. From 1 to 9 there are a few examples of mark making. These are just a few ideas to encourage you to experiment with the medium. What I advise is that you make as many potential marks as you can, so that you build up a glossary of mark making that can effectively be used in the future when and where appropriate.

1/ Lay a piece of charcoal about 1" to 2" long flat on the surface of the paper. Then twist it creating a circle. Repeat this process in a pattern and you create a texture.

2/ Lay the same piece of charcoal flat on the paper then move it across the paper in a wave like fashion. Repeat this motion slightly over lapping the first row and you can create a knitted type texture.

3/ Do the same as number two but in a more geometric manner.

4/ Take the same piece of charcoal and drag it to create a dash like mark. Repeat this at regular intervals. If you are drawing a building with many windows this is a very useful solution to that visual problem.

5/ Do the same as four but angle the mark. This textured mark could be used for the implied surface of a woven basket, or the surface of a parquet floor.

6/ Take the charcoal end. Using it on its side make a small arc by pulling the charcoal in that direction. Repeat the process as a reflection of the first arc, and then make a row of these marks. This tends to give the impression of a woven texture usually seen on basketry.

7/ A similar process as number 6 but one makes an angled mark this gives the impression of a rope.

8/ Pulling the charcoal across the surface in an horizontal direction creates very tight lines giving the impression of wood grain.

9/ Similarly drawing parallel wavy lines can produce a different type of wood grain.

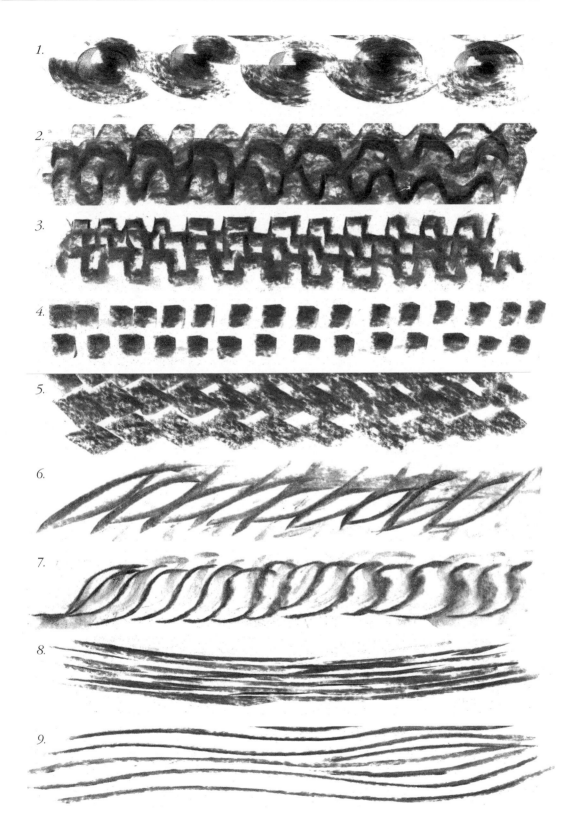

1.

2.

3.

4.

5.

6.

7.

8.

9.

USING ERASERS TO MAKE MARKS

The eraser is a very useful tool when used in conjunction with the charcoal medium either to make marks or to enhance the tonal qualities of a drawing. Making a reduction tone drawing can be a very effective way of creating a drawing. It also makes one think of the eraser as a positive tool rather than something that is used just for erasing mistakes. Like the other mediums, one can devise ways of using the eraser to create a glossary of marks that can be used as an expression for our observations. A good tip is to always keep the eraser clean. One can do this by rubbing it onto a clean surface, or if it is a plastic eraser, it will stand washing.

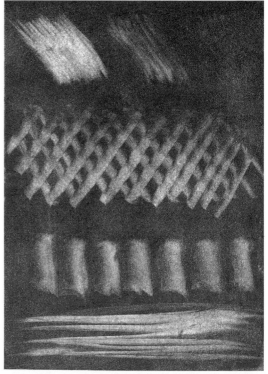

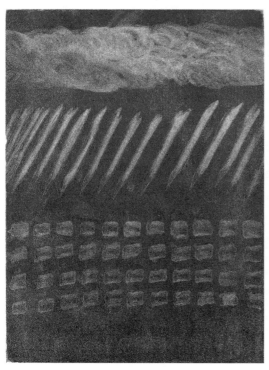

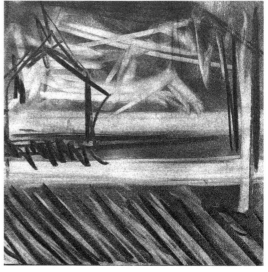

An eraser was used to give this picture its tonal qualities.

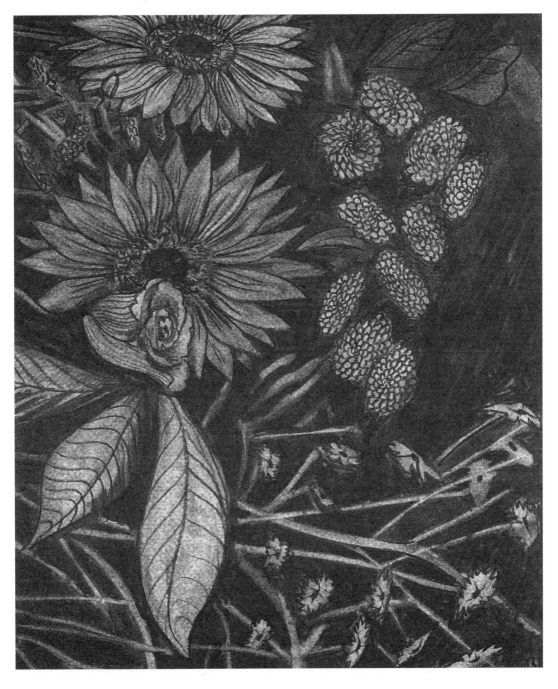

TONKING

Tonking is a well-established way of erasing or knocking back a charcoal drawing. It was devised, I am led to believe, by one Professor Sir Henry Tonks.

1/ Sketch your drawing in very basically using line to establish the composition. Then apply the tone from your observation to the drawing. Do this in a very broad way giving the drawing a black and white appearance.

2/ Take a soft cloth and beat back the drawing dispersing the tone, and at the same time knocking back the tonal density of the whole drawing. This gives the drawing a very atmospheric feel and leaves us with the ghost of the first drawing.

3/ You are now in a position to re-establish your drawing both compositionally and tonally until you have created the effects of chiaroscuro (light and dark). This process can be repeated many times until you are satisfied with your drawing and you have bought it to a satisfactory conclusion. Now 'fix' the drawing.

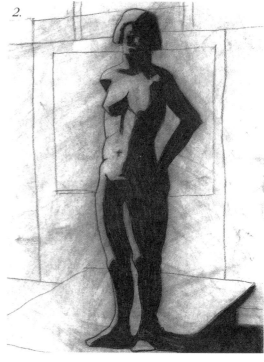

1.

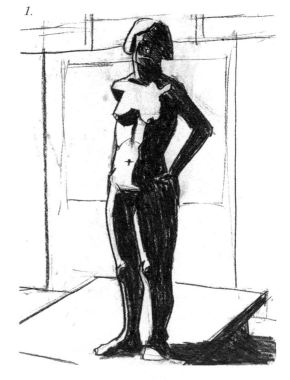

2.

3.

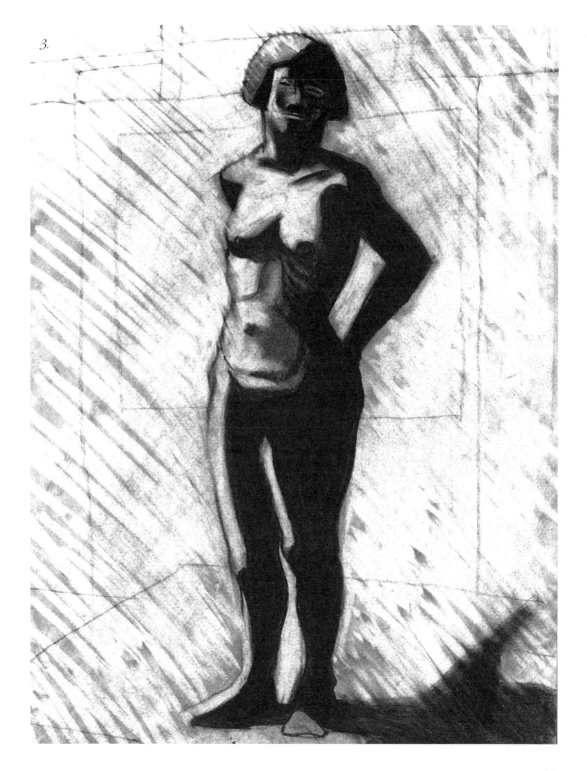

Tonking can also be applied to still life subjects. Here each object is given form by the selective application of the technique.

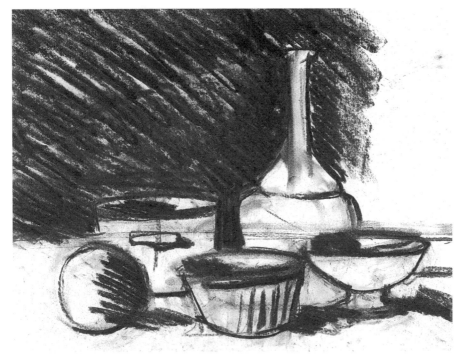

Establish the composition.

'Knock back' the drawing.

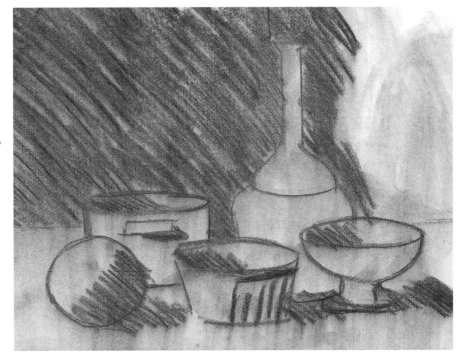

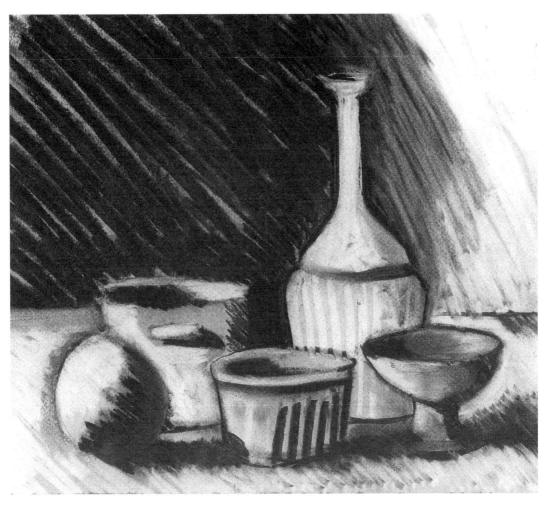

Re-establish the tone to give each object clear shape and form.

Ways of holding the charcoal

HOLDING THE CHARCOAL

Holding the charcoal can be very different to holding a pencil. The charcoal medium is usually used with speed and lends itself to a more sketching approach to drawing. It is not usually used for detailed drawings and is used more broadly as an expression of our observations. So therefore, the way we approach a charcoal drawing can be very different to how we would usually do a pencil drawing. When we are doing a pencil drawing we tend only to use hand and wrist movement, but when doing a charcoal drawing, we almost always tend to use our hand, wrist and arm as well in the action of the drawing.

FOUR WAYS OF HOLDING THE CHARCOAL

1/2/ This demonstrates the two ways that are mostly preferred for sketching with charcoal.

3/ Making a mark using the charcoal as demonstrated in number 3 we can make a very sharp cutting line. A line that feels as though it has been incised on the paper. We do this by taking a piece of charcoal that is about 2" long and place it flat on the paper. Holding it between your thumb and fingers pull the charcoal a long the paper support whilst applying pressure. You see that this mark has a character of its own.

4/ Matisse - when in later life he had difficulty holding charcoal he would tape scene painters charcoal to a stick and make rather large drawings. This drawing would be completed quite a distance from the support so the drawing had a beautiful simplistic quality to it with broad sweeping lines.

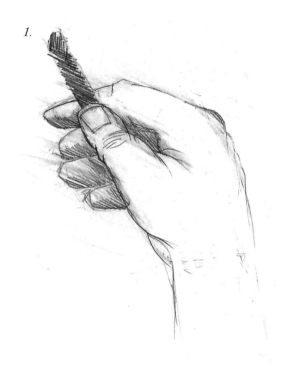

1.

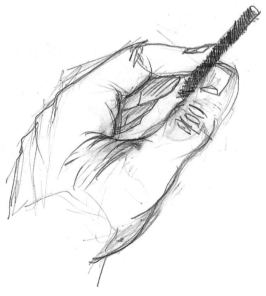

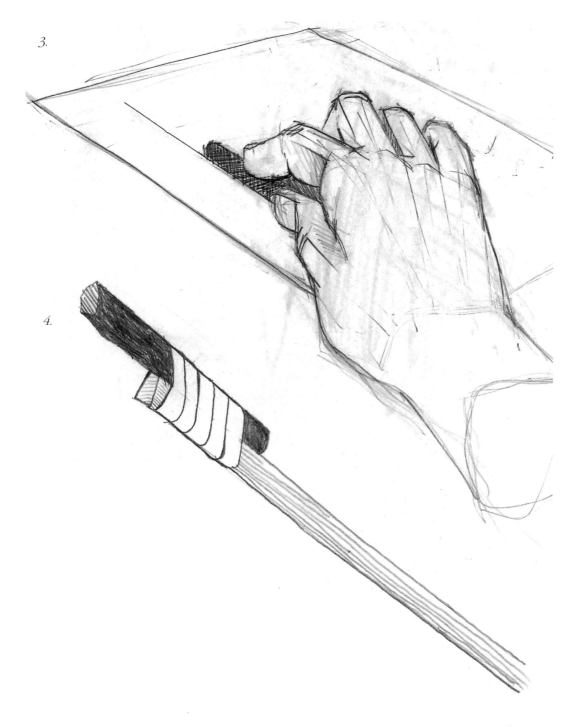

3.

4.

Other forms of charcoal

THE CHARCOAL PENCIL

The Charcoal pencil is rather like an ordinary pencil, but it has the sensitivity of charcoal and yet at the same time a degree of control that a pencil has.

1/ Diagonal shading used in a sketching technique.

2/ A series of vertical lines.

3/ Vertical squiggly lines.

4/ Vertical and horizontal squiggly lines.

5/ Horizontal dashes.

6/ Varied directional marks.

7/ Dots.

8/ Diagonal lines.

9/ Light horizontal lines.

10/ Vertical and horizontal lines moving from light to dark.

11/ Squiggly lines.

12/ Right angle lines going from light to dark.

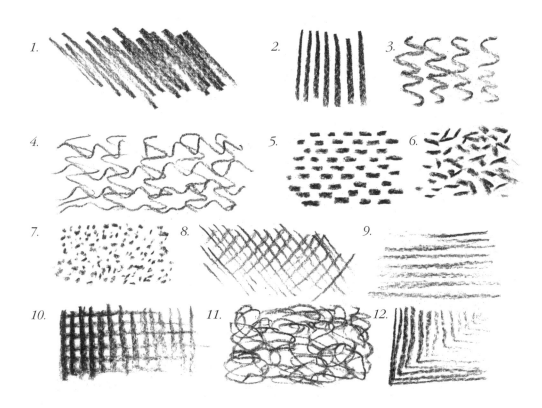

SCENE PAINTER'S CHARCOAL

Scene painter's charcoal is much thicker than ordinary charcoal, and is used to make broader, bolder, thicker lines and tones to fill larger areas more quickly.

1/ A broad thick wavy line.

2/ A broad straight line.

3/ Small dash like marks in rows.

4/ A dark tone.

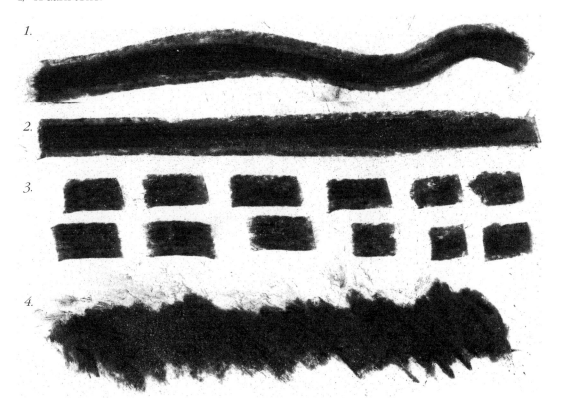

CONTE CRAYON

Conte crayons come in oblong sticks and in a limited number of grades from soft to hard. The conte crayon is a very traditional material and is made similarly to compressed charcoal. It is a finely ground powder that is mixed with a binder and formed into long sticks. It is more solid than compressed charcoal, and this characteristic makes it very different to charcoal in that it is not as atmospheric in nature. Conte crayons lend themselves more easily to mark making and a technique called frottage.

The marks made with the conte crayon from 1to 16 are controlled marks that imply textures. Using marks we can imply surfaces that are rough, smooth, soft, hard. We can suggest through mark making the illusion of wood, metal, string, sponge, and so on. Once one has found a method of utilising mark making, the drawings themselves tend to become a technical process rather than to do so much with the creative act. However, as with perspective the results of this type of drawing can be impressive.

1/ 2 Marks that imply a woven or knitted surface.

3/ Marks that imply a wooden surface.

4/ Marks that imply a carpet or grass.

5/ Marks that imply a woven pattern (a candle wick bed spread).

6/ Marks that imply a woven pattern like a straw hat.

7/8/ Rope and string implied marks.

9/10/ Honey combed or circle patterns.

11/ Marks that imply the bristle of a brush.

12/ Marks that are implying a sharp hard surface.

13/ Marks that imply tufts of grass.

14/ Marks that imply the nature of leaves.

15/ Marks that imply moving water.

16/ Marks that imply rippled water.

1.

2.

3.

4.

All these marks are just to set an example of what you can achieve. So be prepared to make your own contribution to this glossary. So experiment with your medium and make a whole new series of marks, as all this will add to your fundamental drawing experience that will enable you to express your ideas with confidence

Charcoal projects

APPLYING MARK MAKING

We are now going to do a series of studies and drawings based in mark making. These drawings are textural drawings, and are standard drawings for students of the arts.

Having practised mark making we now need to apply that experience. Firstly, it is advised to make studies of objects that have obvious textural qualities. The drawings that you make of these objects should imply the textured surfaces.

In the examples of the drawn objects, you can see that the textures is the main force of the thinking behind the drawing. You will also notice that the texture in the drawings are not an exact copy of what is seen but a metaphor (something that acts for something else) for the surface. Draw as many textured objects as you can as this makes for good practice.

In these examples, I have made some close up drawings from nature, and inanimate objects from a textural mark making approach. The way in which we do this is to draw the basic outline and structure of the object first. Then the idea is to fill it in with marks that give the sense of touch that the object has, and how it looks.

In example 1, we have a small ear of grass. The main area of texture here is in the little seeds of corn and how they are formed. All these examples are constructed out of a type of microscopic observation.

In the second example, we have the closed buds of a flower and the ribbed effect of the stem. In this drawing, there is a contrasting approach of styles. There are the carefully drawn structures of the buds and the stems compared to freer drawing at the top of the buds where the flowers are trying to appear and some leaf formation around the neck of the buds. This contrast in the drawing techniques makes for a more visually exciting type of drawing.

This approach is carried through into the third example of a flower. The carefully observed structure and texture of the stem has been drawn with consideration and a formal approach. Whereas the flower part of the drawing has been drawn more quickly using an appropriate mark to suggest the texture of the flower.

In examples 4,5,6,7 and 8 we have a very well organised formal approach to the production of the drawings. These studies were drawn in a structured and well thought out way. Laying down a series of logical marks within the structure that perform a visual textural manifestation of the plants, that is both exciting and pleasing to the eye and the intellectual inquiry it evokes.

One should look at the studies of nature from Leonardo da Vinci. These observations from nature are so compelling. We can also take inanimate objects and treat them in the same way. Take for example the drawing of the sandal; it is composed of many different marks that bring the sense of texture and character to the drawing. One should also look at the studies of old boots by Van Gogh.

9.

10.

11.

12.

TEXTURED STILL LIFE

Next we look in detail at a very fine example of a textured still life drawing. You can see that there are many objects that have definite textural qualities to them, and they lie juxtaposed to each other to give a textural diversity to the group, which in turn makes the group composition visually very exciting. To make a drawing like this you need to select a number of textural objects, put them together in an interesting composition, and place the textures in such a way that they complement each other. For instance, put rough against smooth, furry against shiny, hard next to soft, and so on. Use a window mount to frame the composition, selecting the most interesting array of textures. Start by drawing the outline of your objects through the window mount. When you have completed this task, you can fill in the textured areas.

You can construct the drawing and establish the composition by using as your example the Van Gogh copy of sunflowers on page 40. Having successfully drawn the outline of your objects in the composition, you can now start to make the drawing. Use mark making that expresses the idea of texture and surface. The best way to approach this is to experiment with marks that might imply the textures that are present in the still life. When you are happy with your results, apply them to the appropriate part of the drawing. In the series of drawings shown over the next couple of pages, we can analyse how we have achieved this.

1a/ The straw hat has many textures that make it a visually dynamic object to draw. The basic construction of the hat is made of a series of lines that follow the form. Between these lines is a series of marks, which forms the implied pattern of the woven texture of the hat.

The woven texture of the hat then opens out to a broader weave, leaving air-type holes that help to keep the head cool. In the analysis of this texture one can create the rendering of this surface by drawing first a series of crossing bands. This gives us the negative holes in the hat pattern, which we tone in as a black shape, which in turn implies the holes in the hat. It also gives us the positive weave pattern of the straw, in which we place the mark of the woven texture.

1b/ You can see that we have started to construct it in the same way as the previous band, using a series of bands that cross over each other to create a diamond type pattern. We have then uniformly filled in some of the pattern of the diamond shapes with a black tone, leaving us with a crossover band pattern. This crossover pattern has a woven stitch texture. This is done by placing a little black mark that forms the pattern of the stitch on the bands. At the top and bottom of the band there is another type of stitch. This is put in by a series of small vertical lines that follow the edge of the band.

2/ The broccoli is drawn, and then texture is implied by a series of tiny little dots or circles placed tightly together to give the textural impression of the flowering of the broccoli. The stem is drawn using a series of parallel lines that echo the form of the stem.

3/ The cabbage is drawn using a number of organic type shapes that follow each other's contours and the form of the cabbage. Leaving a small uniformed space between the shapes that act as the veins of the cabbage leaf. The shapes are then shaded in with a very dark tone to give a very convincing impression of the leaf.

4/ The celery is simple. Draw the structure as with the other objects. Then it's just a matter of putting a series of straight lines that run close together down the stem of the vegetable.

5/ The onion is similar to the celery in that you again draw the structure first, and then draw the lines that imply the outer layer of the skin that forms the bulbous effect of the onion. At the top of the onion draw in the leaf type growth. Putting in such finishing touches to the texture will make the object just that bit more convincing.

The finished drawing.

Other examples of finished textured still life.

TEXTURE STUDIES FROM NATURE

Here we have more excellent drawings from students who have applied their knowledge of texture to another subject - nature. Firstly, as we did with the previous drawings the students have focused in on single objects from nature. These drawings can quite easily be done in sketchbooks out in the field or brought back into the studio environment.

This research is a way of storing information for future use, and indeed if you look in the sketch books of artists such as Leonardo da Vinci you will see his studies from nature, and they are an inspiration. This type of work is a visual enquiry and essential spadework needs to be done by students who wish to acquire the visual knowledge that is needed to produce more established works.

TEXTURAL LANDSCAPE DRAWING

After completing your many studies from nature, you should be able to now move out into the landscape and make a more comprehensive study of the subject. As with the other drawings you first need to establish your composition - do this using your viewfinder or window mount. Draw in lightly the outline of the composition. Once you are happy with the structure of the drawing you can now go over it with conte crayon. Now you need to place in the texture. Here is an explanation of the type of textures that we have encountered in this drawing:

1/ A series of oblong shapes with some indication of shaded texture to give the implied texture of stone.

2/ The roof tiles on the side of the house are layered over each other, with the underside of the tiles being drawn in slightly dark, and heavier than the top of the tiles this gives the impression of the shadow being cast by the tiles. This in turn brings a three dimensional quality to the drawing as well as a sense of the texture. Also in figure 2 we can see the brick is shown in situation.

1.

2.

3.

Staying with example 2, we can see how the tiles on the lower part of the building are demonstrated by a series of horizontal lines that run parallel to each other. These are then broken up by a series of diagonal lines that follow and imitate the pitch of the roof. Finally, the doors and windows are filled in with vertical lines. The lines on the door give the impression of wood and the lines on the window give the impression of the reflection of the glass.

3/ In these illustrations we see that we have a variety of marks that imply different types of vegetation. Such as scrub type bushes and two different type of foliage. We also have different marks for the trunks of the trees.

The drawing in the below example relies on tone, and the texture is made using the rough surface of the paper.

COMPRESSED CHARCOAL

Compressed charcoal is made from finely pulverised high-grade hard charcoal. It is compressed into round sticks and held together with vegetable glue. The soft brittle consistency of the compressed charcoal enables you to create very dense black velvet tones. The tonal value of the charcoal can also feel harsher when applied to the surface of the paper compared to the quality of the tone made with the natural charcoal, which appears much softer and airy.

1/ A broad mark made by dragging the charcoal across the surface of the paper and applying different pressures.

2/ A dense tonal gradation from light to dark. You will notice how much stronger the black of the compressed charcoal is compared to the black of the natural charcoal.

3/ A tonal area created by horizontal and vertical lines. These marks are made by using the side edge of the material.

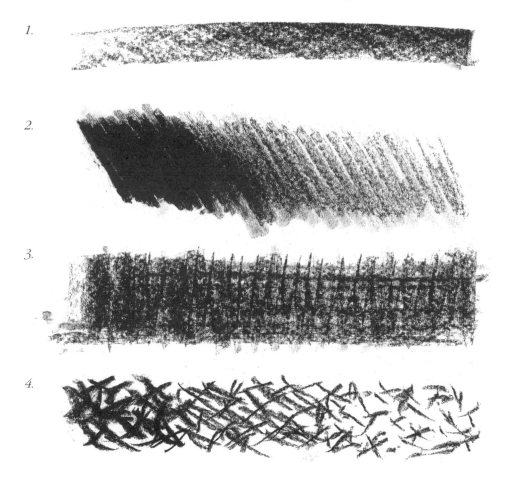

1.

2.

3.

4.

4/ A series of random marks that move from darker more intense to lighter more open.

5/ A sphere created by placing the side of the charcoal on the paper then drawing a circle with it putting more pressure on one side of the circle to give the impression of the form through the illusion of light and dark.

6/ Using the side of the compressed charcoal make a dark square, lay beside it a similar light square. This gives you the illusion of a box.

7/ Closed vertical lines creating tone.

8/ Vertical, horizontal, and diagonal lines creating a crosshatch tone.

9/ Open vertical lines giving a visual striped impression.

10/ Diminishing right angles fading in tone from front to back giving the illusion of space.

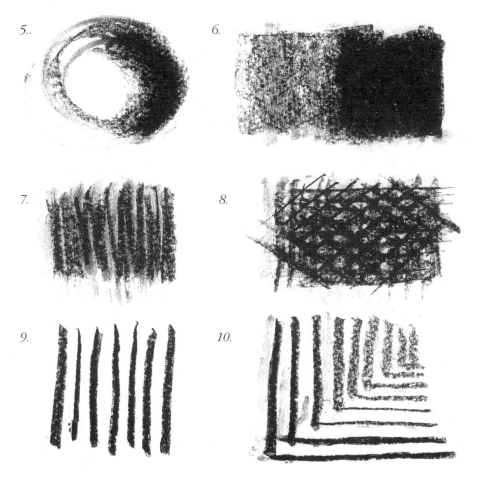

5.. 6. 7. 8. 9. 10.

Compressed charcoal – projects

FROTTAGE

Frottage is a French term and it means to take an impression by rubbing. We have probably all done some frottage at some point or other. Have you ever taken a rubbing from a coin when you were little? Then that was a work of frottage. Brass rubbing is another form of frottage.

As a drawing technique and process we can expand and use frottage as a tool to express our ideas and it has been used by many artists particularly in the twentieth century for this very purpose. No less an artist than Max Ernst used this process to great effect in the early part of the last century.

We make frottage very simply. You need some cheap, thin newsprint paper, some compressed charcoal, some fixative, and an open experimental attitude to your resource material. This being any form of surface that has a texture that you find interesting.

We are going to create a drawing from frottage. Our subject is a landscape because landscape lends itself very much to this process. Firstly, you need to collect a number of rubbings (frottage) from a variety of textures that you can find in the environment around you. Do this by simply putting the paper over the chosen texture and then place the compressed charcoal on to the paper and rub it firmly over the top. By doing this you will recreate the texture underneath. Do this many times over many different types of texture as this forms your resource material for making the drawing that will take the form of a collage (collage is a picture which is built up wholly or partly from pieces of paper or other materials). These surface textures you are creating can

be regular and geometric or from nature. Ensure you fix the impression as soon as you have made it to preserve it. Now you have collected your source material you can now think about the next step in this process.

The landscape we are going to produce needs to be researched. For this, you need to make some basic sketches of the view you have chosen. It would be useful to do about half dozen drawings from different viewpoints, giving you a greater choice of subject matter when you come to do the finished work at home or in the studio.

To start, you need to transfer one of your sketches to a larger piece of paper, preferably A1. The sketch you choose should have a good sense of depth to it. For example it should have a composition that contains a clear foreground, middle ground, and identifiable horizon. Do this in a linear way, drawing around the shapes of the areas that occupy the landscape, creating what appear to be silhouettes around the objects.

You will need to fill in these shapes with textures from your research, to give an impression of the landscape you created in your original sketches. You also might find that you have to make more frottage for particular areas in your picture.

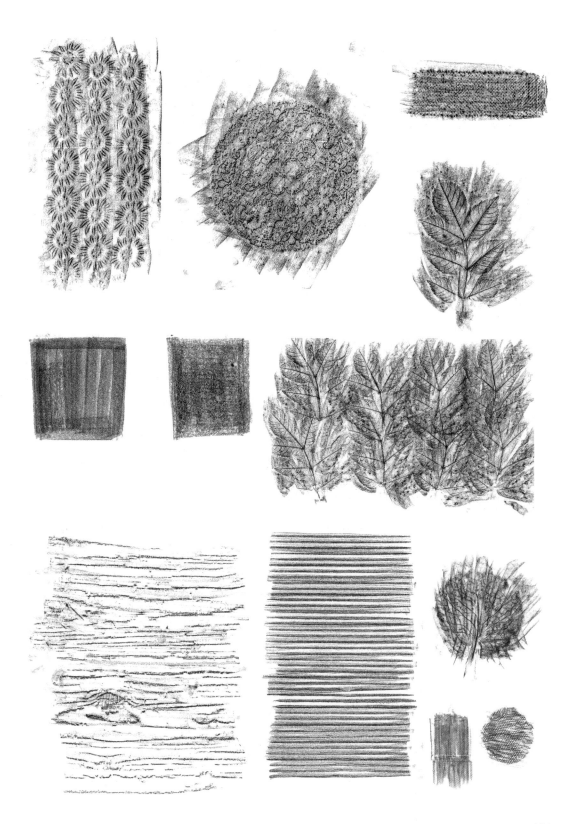

THE PROCESS

1/ Transfer the basic sketch to an A1 piece of paper. We have established the basic composition, and the space of that composition is well organised on the piece of paper.

2/ Take pieces of your frottage and establish where you would like to use them on your drawing.

3/ Always start at the what appears to be the furthest point away in the picture when you decide to stick down your first pieces of frottage. This is usually the horizon or somewhere in the sky. For sticking, I would recommend any type of paper glue.

4/ Start to stick down the textures you have cut or torn to an appropriate shape that will roughly fit the background shape in your drawing.

5/ Once you have layered on the background you can move forward to work on the middle ground. It now becomes obvious why we work from the back to the front in this drawing as it makes covering up mistakes easier.

6/ When you have completed the middle ground you can now move on to the foreground and finish the drawing. Putting any final changes to it that you might deem necessary.

It is always worth spending some time putting in final changes to a frottage composition. Although working from the back to the front of the drawing makes it possible to rectify mistakes as the composition develops, it is the finishing touches that really create a picture to be proud of.

NEGATIVE SPACE AND CHIAROSCURO

Compressed charcoal is very useful for making strong lines and very dark dramatic tones. The next series of examples will highlight how to use the medium for this purpose.

The drawings use the negative space way of working we encountered in the Pencils section; see the examples after Van Gogh beginning on page 40. This well established method entails drawing the space around objects to establish the composition. The second stage of the drawing requires you to look analytically at the nature of light and the way it can be used to describe and express a scene and mood.

Before beginning the drawing, arrange the objects on a table.

1/ Establish the composition on the picture plane, i.e. the paper. You can do this by using a window mount to frame the composition that you like best. A tip - don't make it too complicated.

2/ Start to draw your composition from the edge of the paper. Draw what you see through the window mount. Remember that your window mount should be in scale to your drawing otherwise you will get distortion. For instance, if your drawing is A1 your window mount should be A5. Draw a line that goes over the top of the objects and off the edge of the paper at the other side.

3/ Now go back to the starting point on the other side of the paper, and draw a line that describes the bottom edge of the still life.

What you have produced is an outline of the group of objects.

4/ Begin to fill in the shape and form of the objects.

5/ At this point you need to illuminate the still life group. Set up a light from an acute angle at one side. This will create a dramatic atmosphere by throwing long shadows across the group.

Draw the shapes of the shadows using line. It is important the shadows appear as shapes that exist both on and of the objects. See them as abstract shapes. It will help your understanding if you squint when looking at the group. This action makes seeing the shadows easier.

6/ Fill in the shapes of the shadows with the compressed charcoal, making the shaded areas into a dense black. This will produce a very black and white contrasting drawing.

7/ Smudge the drawing, either by tonking it with a rag or, preferably, by smearing it with your hand. The resulting black and grey tones will give the drawing atmosphere.

8/ Use a good clean plastic eraser to bring back the sharp light effects. Do not be afraid to lose some of the edges of the objects in the shadows – such loss is true to life and a feature of this type of drawing. You do not need to give all the detail. Leave some areas deliberately obscure to allow viewers to bring their own imagination to the piece.

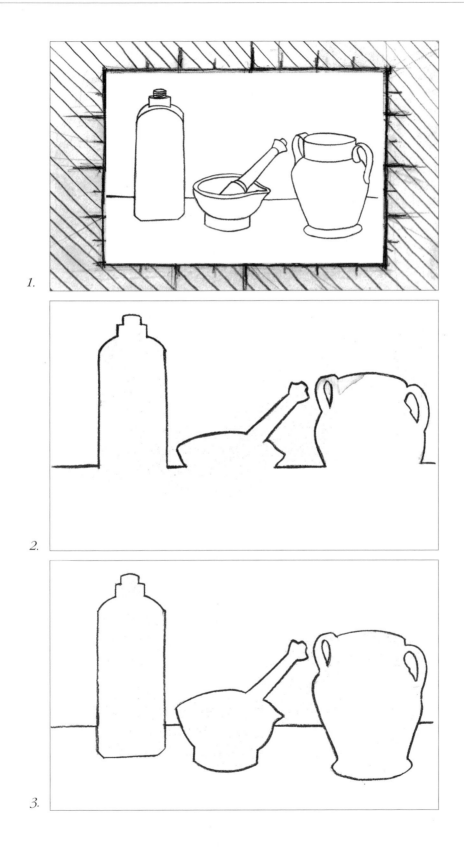

1.

2.

3.

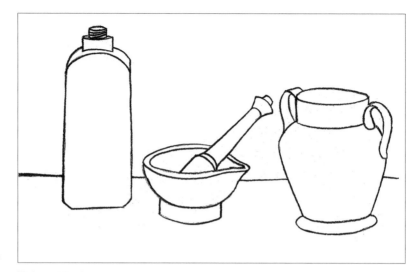

4.

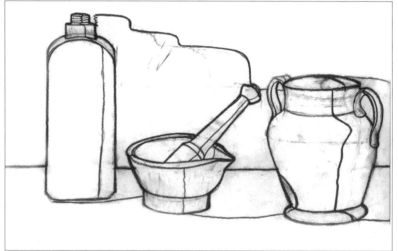

5.

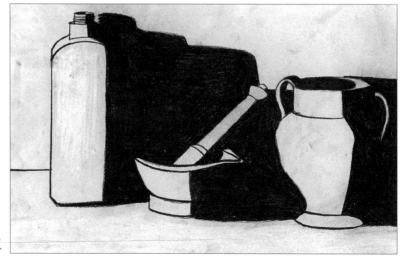

6.

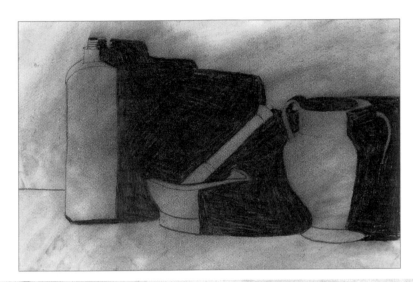

7.

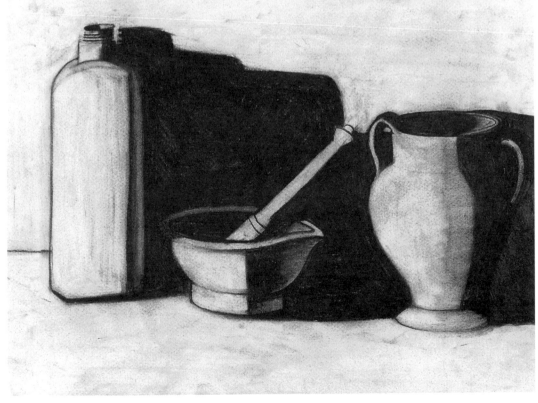

8.

A CONSTRUCTED TONAL DRAWING

COMPRESSED CHARCOAL
DRAWING DRAPERY

Historically drapery has been used for centuries by artists and studied by students and artists apprentices. One has to go no further than the drapery studies of Leonardo da Vinci to see it was an integral part of their research.

There are three drapery projects that are a fundamental to widening our visual literacy, and compressed charcoal is the medium that is most appropriate for this.

Many artists in the past would use drapery as compositional device to create an underlying structure for their work. This process was devised to guide the viewer's eye through the composition.

One of these methods was to create the idea of movement across and through the picture plane using certain effects with drapery to create this illusion. Nicholas Poussin (1593-1665) and El Greco (1541-1614) both used this process very successfully to effect this illusion. What one must realise here is that these effects were not by any means being used naturalistically. Instead they where formal visual constructions to effect away for us to read the picture.

1/ To make a study of this type of work one should first formally set up your drapery still life. Do this by getting a large sheet and twist it tightly and also loosely around a tall object (I use an easel for this purpose). By doing this we have given a sense of movement to the still life. In essence, it is the type of movement you would describe when you see and try to explain a spiral staircase. In setting the group up in this way, we have constructed the idea of an upward motion.

2/ Now set up to draw with a large piece of paper - the larger the better for this drawing. Firstly, draw the outlines of the folds of the drapery using your compressed charcoal. Immediately you will see that you have created the sense of movement up the picture plane through the nature and direction of the line.

3/ We can now give the drapery a feeling of volume that will also emphasise the sense of movement up the picture plane. We do this by adding tone in a very particular constructed way. This process is referred to as front or top lighting and was used by the pre-Renaissance artists such as Cimabue, and Duccio. In the finished drawing, the tone is applied in the same way as you can see in the detail. It enables us to read the simple sense of form. It works in this way. The surface of the drapery that appears nearest to us is left white, and as the surface moves away from us and into any recesses you gradually make the tone go darker until it reaches black at what appears to be the furthest point away see detailed example. The illusion of a shallow sense of depth is created. As you might have guessed this process is very mechanical and theoretical and at this point can be executed without looking any further at the drapery subject matter.

1.

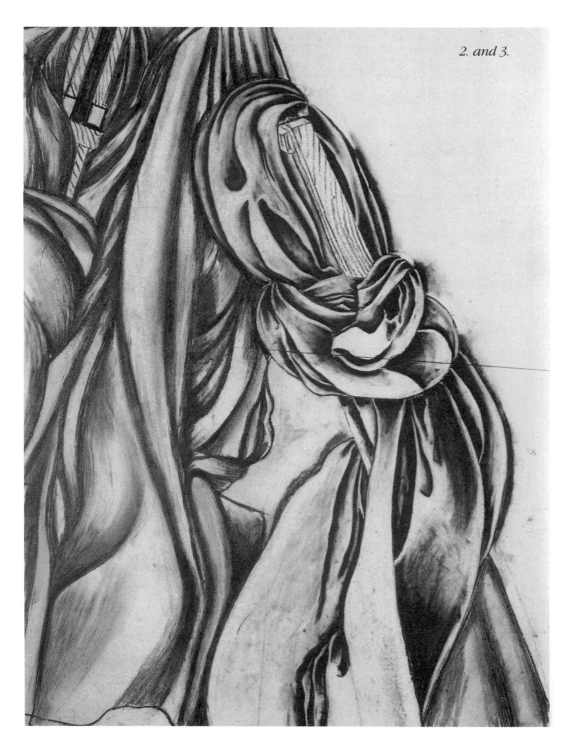

2. and 3.

DRAPERY 2

Another way of working with drapery, which gives a more static effect and is more or less the opposite to the previous approach, in that instead of movement we create a sense of form that has a weight and stillness to it. Artists would use this way of working to create an illusion of mass that would reflect the underlying form. Look at the example below and also refer to the works of Massacio, Cezanne, and some of the works of Picasso.

Drape a large sheet over a simple form (a chair) so it reflects the form of the object. Now proceed to draw this using exactly the same process as with the previous drapery drawing.

TROMPE L'OEIL

Trompe L'Oeil means to deceive the eye, to create a realistic illusion. There are many ways to create this effect, but one of the easiest is by choosing an object that is relatively flat, and can be hung on or lie on a flat surface. In the examples, I have chosen a tennis bat and a gardening glove.

Choose your subject carefully for this. A favourite coat dress or object that you know well, something that when hanging or lying flat would present us with some folds. When you have chosen your object hang it against a flat surface. This eliminates the problem of excessive depth.

You need to light the subject from the side to cast a shadow on the wall behind the subject. Do this by using any light like an angle poise lamp, and directing the light from the lamp on to your object from the side. This type of light source is very important, as the way the light illuminates the subject and the shadows that are cast will create the Trompe L'Oeil illusion when drawn.

You now need to start your drawing with the compressed charcoal, making first a linear drawing as with the two previous drawings, by fixing your composition on the paper as accurately as possible and to scale and proportion. The next part of the drawing is different to the last two drawings in that it is pure and very accurate observation, looking at tone and texture in detail. Pay particular attention to minor detail such as creases, buttons, or lining. See example on page 134. Don't forget the cast shadows.

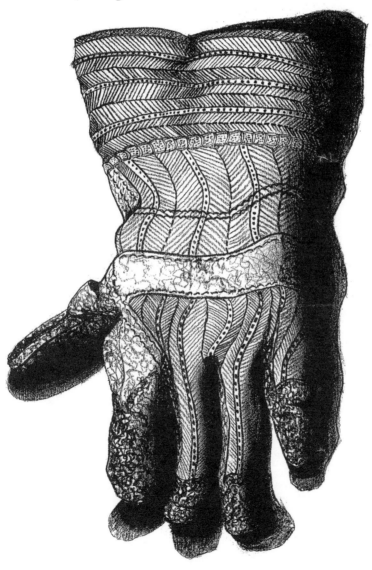

TROMPE L'OEIL DRAWING OF A GARDENING GLOVE

Having drawn out the composition of the gardening glove it is now the time to focus on the complexities of the textures that glove contains. In the following examples I have broken it down to a series of close observations of the way the glove has been manufactured or constructed.

1/ At the opening end of the glove we are first confronted with a hem type stitch, which makes the border of the glove. This is constructed by making a small channel using two parallel lines that follow the contoured edge of the glove. In this channel we now place the pattern of the stitch, and this consists of a series of diagonal lines that go one way. In the spaces that are created by the lines we now place another series of marks that go in the opposite direction to imply the completion of this texture.

2/ We can now begin to observe the texture of the next section of the glove, and this takes the shape of another band that is obviously a lot wider than the first band, so here we have to take into account the relative textural proportions of the glove. This band again follows the contours and the form of the glove, and the texture is constructed by using a series of diagonal lines.

3/ In this example we observe that there is now a smaller band that again is following the contours of the glove. This band is about the same proportion as the first band but the texture is very different. We see that the mark to create this texture is a series of dots that change in the angle of placement, as the nature of the form of the glove changes its angles.

4/ In this example we can see that we now are creating a series of rows of textures that give the impression of a herringbone texture. This is created by putting two rows of the same proportions together, still following the contours and the form of the glove. Then we place in the top band a series of diagonal lines that oppose our first series of diagonal lines, and in the next band we place another series

of diagonal lines that also oppose the lines above. This creates the herringbone texture and pattern that is an essential textural feature for this object. Underneath this is a small band of dots that we did in fig 3, and then you will repeat the herringbone texture again.

5/ This section of the glove is finished off by a different type of stitch. Again we observe that it is a band that is about twice as thick as the smaller band. It is constructed by placing together a series of over-lapping horseshoe shapes, and in the centre of these shapes we have placed a number of lateral marks to give the impression of the stitch.

6/ In this section of the glove we see a repeat of what we have just drawn in terms of the texture. However, the whole direction and the structure of the texture and the form of the glove have changed. The only added textural stitches are the four lines. These consist of little arced type marks that join to form the line that follows the contours and the form of the glove. The main herringbone texture of the glove should be repeated in the fingers of the glove to complete this textural part of the observation.

7/ We now move from the cotton part of the glove to the protective leather part and we examine how we have made our observations for this material. In the drawing of the composition you should have drawn out the areas of and defined the leather parts of the glove, and the drawing of this material will be very different to the drawing of the cotton parts of the glove. When applying our techniques to the cotton parts of the glove the drawing was created in a very constructed way, whereas here for the leather the drawing is more organic in its approach and how we

interpret the texture. The texture of the leather is created by scrawling the compressed charcoal medium over the surface of the paper, applying varying pressures as you go so as to give a variety of weight to the mark. There is however, a small-added piece of texture to this section, which has a constructed formula to it. This is shown by a row of stitches, which creates a line that follows the form of the glove.

Finally, to finish this drawing one needs to put shadows over the top of the texture that are created by the direction of the light source that we originally placed over the subject. Remember also to put on the shadows that are cast on the background that your subject lies on, as this is vitally important in creating the Trompe L'Oeil effect.

The tennis bat is another example of the Trompe L'Oeil and as we can see here it has be constructed in the same way as the gardening glove.

Firstly draw out the composition of the bat as we have done with the other subjects that we have tackled. Once you have the composition firmly fixed on your paper you can now begin to contemplate the textural qualities of the subject.

1/ The stringing of the bat is constructed by a series of marks that implies the woven tension in this section of the drawing. The direction of the marks gives us the tight woven impression.

2/ The construction of the head of the bat is made from wood that has been formed by compressing the material together to make

this unusual structure, and this is implied by the tightly compressed marks that are in the form of lines that follow the shape and form of the head of the bat.

3/4/ The handle of the bat has been painted and therefore its surface is flat but nevertheless it has a shiny quality to it which is implied by the tonal aspect of the drawing. There are also graphic elements on the surface of the handle, which must be copied as accurately as possible. At the base of the handle, we have the leather grip. This material has been wound around this part of the bat to form a pattern. Draw this pattern before you put in the textured marks. The marks that imply the grip of the bat are made by rows of dots that follow the winding pattern of the leather material.

Now you have in place all the textural references you can now put the tone observations over the top putting in the important shadow effects to create the three dimensional illusion that is Trompe L'Oeil.

Willow charcoal – projects

WILLOW CHARCOAL

Willow charcoal is a very good medium for producing strong but fluid line drawings. When we are using line, we must have a clear view of our aims and objectives. This is true of any type of drawing, of course, but line does offer so many different ways for us to express our ideas. One of the most enigmatic things about line is that it is a pure metaphor (a metaphor is something that acts for something else). Artists who paint reference colour, and artists who sculpt reference form or shape. Line is a pure visual language that we can use either expressively or analytically relative to our observations.

1/4 In figure 1 you can see that two lines have been drawn opposite each other. Taken together, these two lines give the impression of a concaved shape. When this type of line is used to describe reality, as in figure 4, it becomes apparent that, although you have drawn or copied what you have seen, the end result does not necessarily describe what is there.

2/5 Here again we have the same problem, one line that implies a concave and the other line implying a convex. When we apply this to reality, or we draw what we see (as in figure 5), we sense that the illusion is not working.

3/6 In figure 3 we see two lines that imply convex edges of a form. These two lines working opposite each other now begin to imply the illusion of an ovoid form that is pushing them out. If you now look at figure 6, you can see that the area of the neck has a sense of form and volume. This is due to the use of convex lines that work in tandem with each other.

7/8 These two further comparisons highlight this phenomenon. Figure 7 is a drawing of a head and torso drawn very literally, as we might see it. In other words, we have drawn the truth. However, 'art is a lie that enables us to see the truth', said Picasso. The dotted lines highlight the concave areas on the figure, and if drawn in a concave way the sense of volume is denied.

In figure 8 we see the same figure in the same pose but drawn with lines that are convex. These lines break into the figure, creating the idea of overlap. This system of drawing gives an illusion of form and volume in space. This is very much how artists such as Michelangelo, Leonardo, Rubens, and others would use line as a metaphor to create the illusion of form and volume in space.

SUPERFICIAL MUSCLE

This drawing of the whole figure (see page 142) goes much further than the pure outline of the previous illustrations.

In the previous illustrations, the form is only suggested by the convex outlines, but in this drawing the superficial muscle - i.e. the muscle that lies just below the surface of the skin – is not only implied but also drawn much more conclusively.

In the next illustration (see page 142) we can see that the artist Egon Schiele has used the line to express the opposite effect to that of frailty and fragility. He has done this by putting less of an emphasis on the convex and more of an emphasis on the concave lines. We can immediately see that the form in these circumstances tends to be denied. This, however, does not make one drawing better than the other. Both are expressions of what the artist wanted.

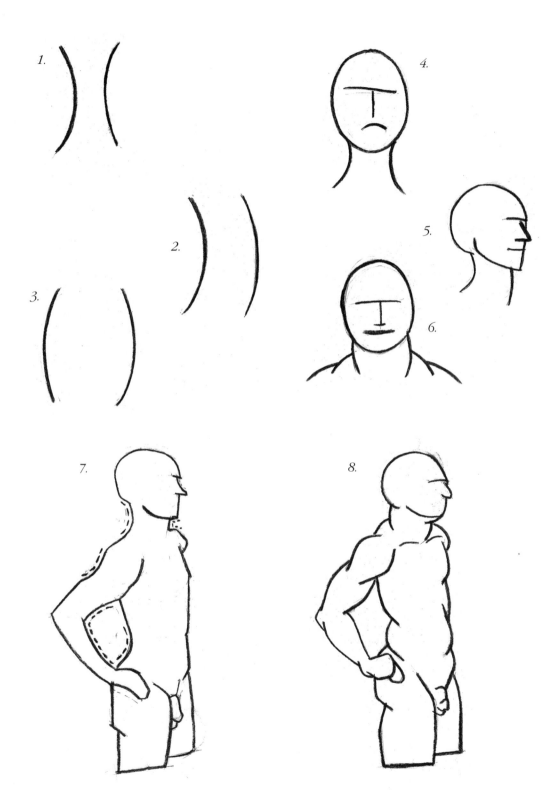

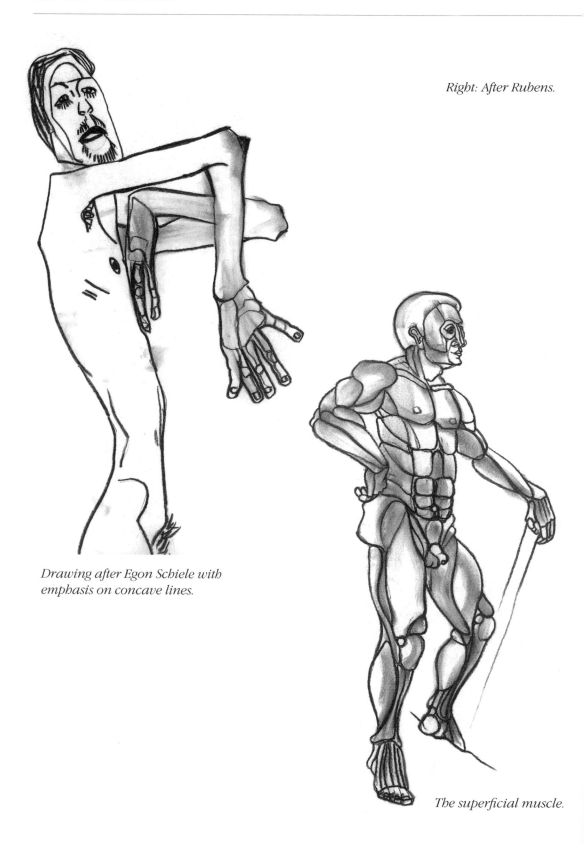

Right: After Rubens.

Drawing after Egon Schiele with emphasis on concave lines.

The superficial muscle.

THE INCISED LINE

The incised line is a line that seems to cut across the paper implying a sense of direction. It is made by using the charcoal on its side to make this precise line. This method of drawing not only picks up the dynamics of direction through the outline of the figure, but at the same time it informs us of the changing planes of the form within the figures.

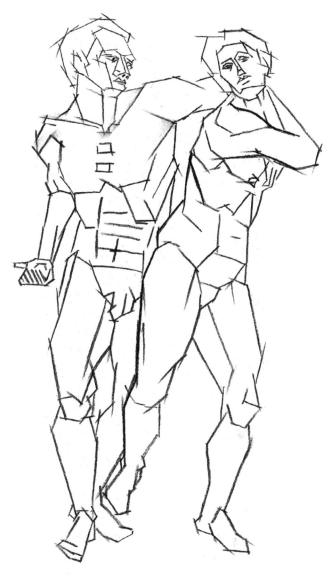

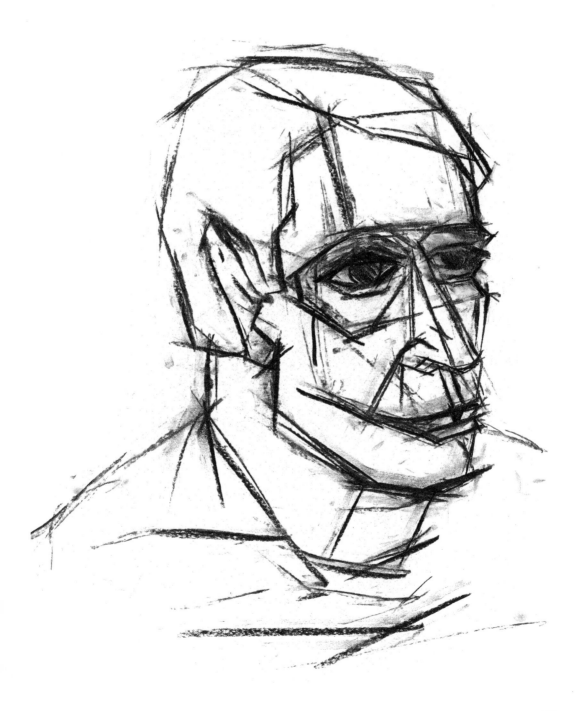

MOVEMENT

In this next series of drawings, the medium of charcoal will be used to show an expression of movement.

1a/1b Place a number of drawings of different poses one over the other as seen in the illustration. Pose the model; make the drawing of the model using outline as previously suggested. Pose the model again and make a further drawing over the first drawing, and repeat this process again. On the third drawing you will start to become lost and a sense of confusion will be what you are feeling. This is a sensation that we want to create, as it is only when you are lost that the

1a.

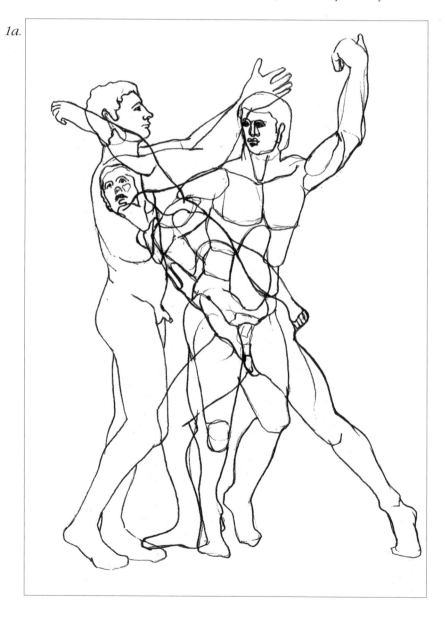

drawing can be found. This is a very useful drawing for students as it helps to develop an abstract sensibility. What we have created here for the artist is a very important state of mind, as you can now develop the drawing's potential as an abstract piece. One way of doing this is to take a small window mount and start to place it over areas of the drawing. You will find that interesting developments appear for you to make larger drawings from.

1b.

1c/ As with the first drawing on movement, take a window mount and place it over the drawing to create new dynamic abstract compositions. From these discoveries you can make larger exciting drawings.

2/ Instruct the model to move through a series of actions, for instance walking then bending. While you are doing the drawing, the model should repeat these movements at the same pace. Start your first drawing at a very slow pace. As you get used to the method of drawing, you can then speed up. Remember you are not drawing the model but the action. What you are trying to draw, using line, is a continuous flow that gives a sense of the action of the model as they move through space and time. The best type of line to use for this is what artists call 'continuous line'. This in effect means that you do not take the charcoal off the paper as you are making the drawing. However, you should allow for different weights of mark that express movement both across and into the picture plane.

2.

THE MOVING VIEW

Before the 1900s artists would realise the world from one point or view. The viewer would be presented with that view and would understand the scene from that perspective. This was a traditional way of presenting our understanding of the world two dimensionally that had been used for centuries in a western cultural ideal. However, our attitudes began to change at the beginning of the 20th century, and other ways of seeing began to be explored. Our attitude to the one point view began to change. Artists such as Picasso and Braque began to experiment with multiple views of the same subject on the same picture plane. What they intended to do was to present a view of reality along with another view of the same reality on the same piece of paper. Hence the birth of Cubism.

The moving view is the perfect way for us to extend our understanding of the world visually using the medium of willow charcoal.

1a/ Set a simple still life up on a table or a board that you can easily rotate or move around to take up different positions. The

1a.

objects you choose for your still life should have basic formal different characteristics. Position one of the objects in the group in a central position; this is for reference reasons in the following drawings.

1b/ Take up your first position and then draw your still life after the manner of the negative space drawing, locating your composition through the window mount.

1b.

1c/1d The next part of the drawing is to move your position or turn your still life around on the table so we are now looking at the group from the side. Start your second drawing over the top of the same drawing using the central object now as your reference point to compose your drawing. This point will be your main point of departure for your next drawing, as it will help you as the drawing develops and becomes more complex.

Repeat for a final time so that your last drawing as it were was from the back view. When you have finished you will have three linear drawings from the same still life done over the top of each other.

1e/ We can now begin to take from this drawing the visual potential it has to offer as with the previous drawings in this section. One way to do this is to take the window mount and place it over the drawing in different places until you find an interesting composition that you would like to transpose. Once you have made your larger copy of this section you can now begin to shade the drawing in as we have shown you in the pencil section – the drawing after Cezanne Landscape.

1c/1d.

1e.

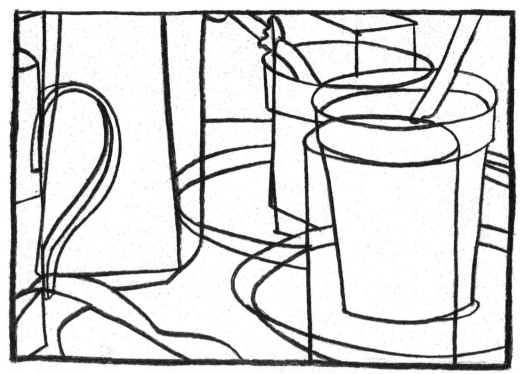

The shaded drawing.

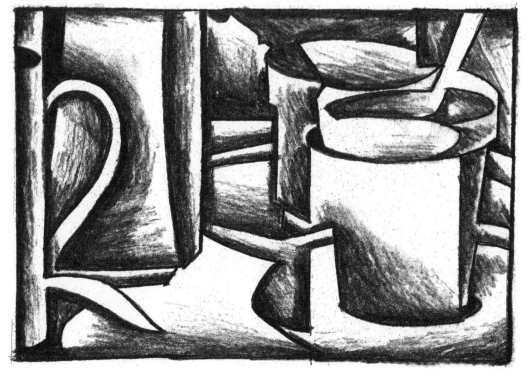

TONAL REDUCTION DRAWING USING SCENE PAINTER'S CHARCOAL

Scene painter's charcoal is very useful for very large line drawings or covering very large areas of tone quickly. In this project, we are going to use it in conjunction with willow charcoal to create a reduction tone drawing.

1/ Take your A1 sheet of drawing paper and using your scene painters charcoal cover the whole sheet of paper so it is black all over.

You now need a good strong plastic eraser to take out the charcoal to reveal the light. It is probably a very good idea to illuminate the still life as we have done here with the floral arrangement.

When you start to rub out the light areas don't be too particular if you rub out too much as we can work back into the drawing at a later stage with the finer charcoal to bring back the detail. However, one should try to make the area as clean and as light as possible to give a good sense of contrast. When you are happy that you have removed the main light areas, you can now think about working back into the drawing with the finer willow charcoal bringing a more accurate rendering of the light and dark tones. In addition, give attention to textural and other detail where necessary. When you have finished the drawing, as with all charcoal drawings, you must remember to fix them.

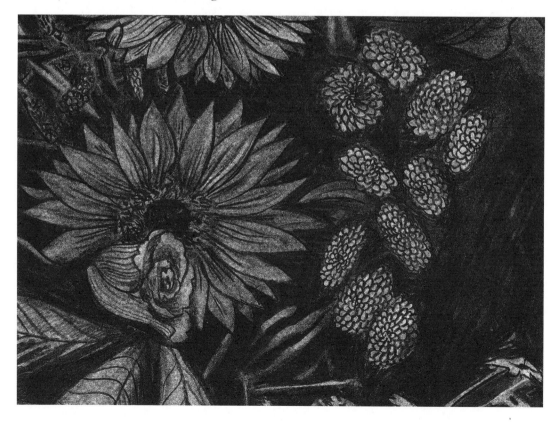

Part Three

PENS, INKS, BRUSHES and PAPER

Fibre tip, ballpoint, dip pen, Rotring, fountain pens.
Inks, traditional brushes, Oriental and flat head. Paper.

INTRODUCTION

If you are an artist of the first kind, one who wants too much control over the processes, you will find this section of the book challenging. Ink in its most fluid form and used in conjunction with non-traditional applicators will expose you to the experience of letting the processes and the nature of the medium be your guide. This approach may bring you unwittingly to satisfactory visual conclusions that you would never have entertained in your work previously. You will find, however, that your innate sense of control will always act as a safety net and stop the processes getting completely out of control. This is exactly the type of balance we should be striving for as artists. 'I do not seek I find', said Picasso.

If, on the other hand, you are a more emotional kind of artist who sometimes becomes frustrated because you have a propensity to allow the process to run away with you, and the results usually end in a

mess, you will find exercises to curb your excesses. Ink will offer you the tight, controlled effect that you may sometimes feel is lacking in your drawing. If you are in this category my advice is to start your drawing with the freedom you feel is necessary to your style - one cannot deny the instinctive flow, it comes naturally. I would do a wash drawing - a landscape would be a good choice of subject - with ink and a flat-headed brush. This combination will allow your instinctive creative energy to be released into the drawing. It is now time to bring that element of control or detail into the drawing that gives it that much needed sense of balance that we have talked about previously. To do this take a rotring pen or a dip pen and put in the fine detail over the freer wash drawing to give it the contrasting sense of tension. We call this approach working from the general to the specific.

DRAWING WITH INK

Drawing with ink is the most exciting drawing material in my view. Although pencil and charcoal have certain attributes and characteristics, drawing with ink is so much more demanding and at the same time versatile. The very nature of the ink as a substance and the multiple ways that it can be applied as a medium gives it a wider spectrum of use both in traditional and experimental ways. Personally, I have found that working with ink can help correct our weaknesses and enhance our strengths. Artists tend to develop traits and these tend to fall into two types. We can be artists who are very much controlled by our intellect or thinking processes, and use our materials accordingly. Alternatively, we can function by allowing the processes to take us to a visual conclusion that is furnished by a more emotional, expressive approach. Each one of these ways of working has to have a bit of the other in it to bring about some form of aesthetic order. Ink is a medium that allows these innate qualities to flourish.

This chapter should not only introduce you to the medium of ink drawing with its traditional uses and its more experimental approaches, but it should also give you the opportunity to adjust your attitude towards your work. This in turn will broaden your visual acumen.

INK AND OTHER MATERIALS

Chinese or Indian ink are the most widely used inks for drawing purposes, including technical drawing, brush drawing, calligraphy, washes, and other ceremonial uses.

Formulas for making ink may be found in specific books, but basically it is the soot of burnt resin or cherry pits mixed with an aqueous binder (a solution of gum water). This is ground together on a marble slab and made into a paste, which is then shaped into sticks and allowed to dry. To make the ink, the stick is then rubbed onto an ink stone or ground glass. This is a stone or a piece of glass that has a fine textured surface, and when the ink stick is rubbed against it, it leaves a residue. The residue is placed in a shallow bowl and slowly mixed with distilled water until the right amount of liquid ink is made to the right strength.

However, bottled Indian ink can be brought from any art suppliers and needs no preparation. It is pure black and permanent when dry. The ink can also be diluted with water to produce washes.

Bistre ink, which was commonly used in Europe between the 16th and 18th centuries, comes in different colours that range from pale yellowish browns to dark blackish browns. Bistre is made from soot containing wood tar. Other tones of colour can be obtained by using different woods. By taking the soot from different levels of the charring one can vary the intensity of the tone. Because of its strength, this type of ink is most appropriate for use in washes. Rembrandt was possibly the best-known artist for using bistre.

Sepia is obtained by mixing bistre with the ink obtained from the sacs of squid. This was what Professor Seydelmann of Dresden did in 1778, and in the process invented a drawing medium that is stronger and darker than bistre.

FIBRE TIP PENS

There is a vast array of pens that can be used for many different reasons by artists. Fibre tip pens come in many different thickness' and different tip shapes. The fibre tip pen is a very direct medium and they are designed to make very general quick but accurate drawings that are free flowing. It is difficult to correct fibre tipped drawings so mistakes should be taken as a part of the process with this type of drawing. The tip of this type of pen can become worn quite quickly and the sharpness of the mark can be lost. These pens are best used on strong coated papers i.e. Bristol board. See the example of an artist's impression drawing done with a fibre tip pen. These drawings are usually produced to give an impression to a client of a proposed site, and are usually completed with a hint of colour. One can get fibre tip pens in many colours.

BALLPOINT PENS

Ballpoint pens make a consistent and permanent mark. One can create a dark line or a light line depending on the pressure. Ballpoint pens can be used for both very mechanical or very fluid drawings. They can also be used for making very quick sketches and notes and can be very useful for working in sketchbooks. The ballpoint can also be used on thinner papers, and like the fibre tip pen, it is hard to remedy mistakes. Remember that drawing with this type of pen is usually exploratory in nature so you should accept your mistakes as a part and parcel of the learning process that exposes your thinking procedure.

FELT TIP PENS

Felt tip pens come in all different sizes and shaped tips like the fibre tip pens. These pens are best used for quick drawings and sketches and as with the other pens mentioned so far it is difficult to correct your mistakes. They also come in many different colours, and are often used as calligraphy pens for signs. There is an example of a felt tip drawing on page 185. Here we have a drawing that reflects the use of the different thickness of felt tip pens, and notice the openness and the freedom of mark used to create this drawing.

FOUNTAIN PENS

These are more personalised instruments than the pens previously mentioned, and if you use a fountain pen you should not allow any one else to use it as it wears to your style of writing or drawing with that instrument.

These pens should only be used with non-waterproof ink. Otherwise they will clog up. Non-waterproof ink is also useful for using with bleach to draw. I have not given any illustrations of marks made with fountain pens because they are usually associated with writing rather than drawing.

RAPIDOGRAPH OR ROTRING PENS

The flow of the ink in Rapidograph pens and Rotring pens is controlled through a needle type tube to create a fine definite line. The line produced is even and consistent and nibs of different thickness and grades can be obtained. These pens are used for very accurate drawings and are generally used by professionals such as Architects and Designers. Drawings are usually done to scale and are precise working drawings.

PEN PROJECT: KITCHEN PLAN

This is just the kind of project that, traditionally, the rotring pen has been used for. There are now software packages available that enable you to produce computer-generated plans, but the point of this exercise is to get you to understand the characteristics of a pen that gives a controlled flow of ink through a needle point.

Key
1. Fridge/freezer
2. Cooking hob
3. Eye level oven
4. Sink and drainer
5. Breakfast table/work top
6. Washing machine
7. Man-hole cover
8. Storage and work tops
9. Dustbin

DIP PENS

Dip pens are so called because unlike the other pens mentioned these pens do not supply their own flow of ink - they have to be dipped into a pot of ink before they are able to make a mark.

Mapping pens or nibs are used for very fine detail only and fine cross-hatching.

The different Gillot nibs are designed to give you a more varied line according to the angle that you hold the pen, and the pressure you apply. The flow of ink to the nib from the dip pen is very different to the flow of other pens. It is less consistent and therefore has to be continuously dipped into the ink to replenish your supply. Dip pens can be used very openly and expressively in the nature of mark making or they can be used very finely.

NATURAL PENS AND ALTERNATIVE MARK MAKERS

This type of pen is usually made from natural material, as opposed to manufactured pens. They can be cut and fashioned to produce a more personalised mark. They are usually made from reed quill or bamboo, and are produced to make a broader mark. However, you can make nibs for your own needs with a sharp knife, razor blade or a quill cutter. One can also make marks with other materials cut into nibs. Here are a few suggestions. A plastic straw can be cut and used as a quill, or a sharpened matchstick or a piece of twig. Almost anything can be of use to dip into the ink to draw with. So do not be afraid to experiment with your drawing implements.

Dip pen.

Natural pen.

BRUSHES

To put washes down on the paper when working with ink usually means the use of brushes. On the other hand, we can use the brush for what we call brush drawings.

The Chinese and the Japanese still use brushes as drawing and writing implements. The brush is also still used in these cultures for ceremonial purposes. Brushes are very versatile, and they are usually made of sable. Sable hair is very consistent and doesn't lose its tension in the mark making process, springing back to its shape and form and remaining very firm when pressure is exerted. It is essentially a brush that keeps its body and can be relied upon for consistency when you are working with it. Sable brushes are expensive to buy, so it is wise to look after them. Never leave them standing in ink or water for any length of time and always clean them after use in the appropriate solution; for the inks we are using that solution would be water. Make sure you dry them and that you store them carefully so as not to damage the bristles. If you cannot afford sable brushes there are other less expensive alternatives. These brushes are usually made from ox hair, squirrel hair or some form of synthetic material. I would also suggest that you try any brushes you already have, just to see what effects you can create with them. Brushes that we have tired of and put to one side can often be very useful for mark making.

Between pages 172 and 176 we look at examples of mark making with three different types of brush: an Oriental brush, a flat head brush; and a round head brush, which is a Western version of the Oriental brush.

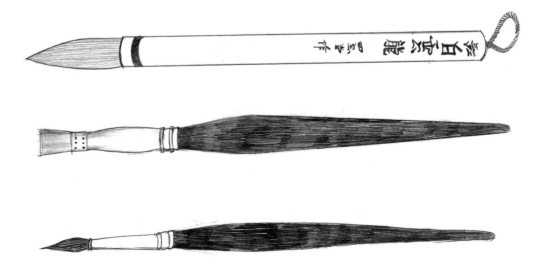

PAPER

The paper you choose to work upon should be brought with the type of work and materials you are going to use it for in mind. Inexpensive papers can be used for quick sketches, working on them with manufactured pens such as the ballpoint, fibre tip, felt tip, and rotring pens. However, if you have something specific in mind then you need to choose your paper carefully.

BRISTOL BOARD

This is a hard white board that is smooth and is used by designers for fine pen work. Because there is no texture and the board is like that of a laminated surface it enables the type of pens used by designers such as rotring pens to glide across the surface of the paper and give an accurate line that is needed in some of these drawings.

CARTRIDGE PAPER OR LEDGER BOND PAPER

This is the commonest form of paper for pen and ink drawing and is available in a variety of surfaces from smooth, semi rough, to rough, and it can be used for pen, brush, and wash work. For brush and wash work it is advisable to stretch the paper (see stretching paper).

WATERCOLOUR PAPER

These papers are very useful to use, particularly for brush and washes. They do come in a variety of thickness' and weights of paper and different textured finishes. They should also be stretched before working on them.

SKETCHBOOKS

When working with manufactured pens sketchbooks are necessary. They act as visual diaries, where you can put down and record your first thoughts, visual jottings, and notes for the future. They are designed to be carried around with you to record your observations, and to gather information. They come in various sizes from A5 to A1, and you can get various types of paper, from cartridge paper or ledger bond paper to watercolour paper.

STRETCHING PAPER

If you intend to work on paper using washes or a watery solution you need to stretch your paper first in order to stop it buckling. The fibres of the paper will expand when they come into contact with water making the surface of the paper very difficult to work on.

The process is very simple but allow plenty of drying time for your preparation.

Step 1/ Place your paper in a tray of water for at least five minutes or longer. This allows the fibres of the paper to expand.

Step 2/ Place the wet paper on your drawing board but dampen the surface of the board first.

Step 3/ Fix the paper down using gum strip. Wet the gum strip and place it round the four edges of the paper so the biggest proportion of the tape grips on the paper. Do not worry if you see bubbles on the paper at this point as the paper will shrink when it dries to a smooth tight finish.

Step 4/ Leave a small pool of water in the middle of the paper. This enables the outer edge of the paper (where the tape is) to dry first, allowing the tape to fix the paper firmly before its starts to shrink. Allow a good half a day for the paper to completely dry and then you will have a smooth surface to work on that will take water without it buckling.

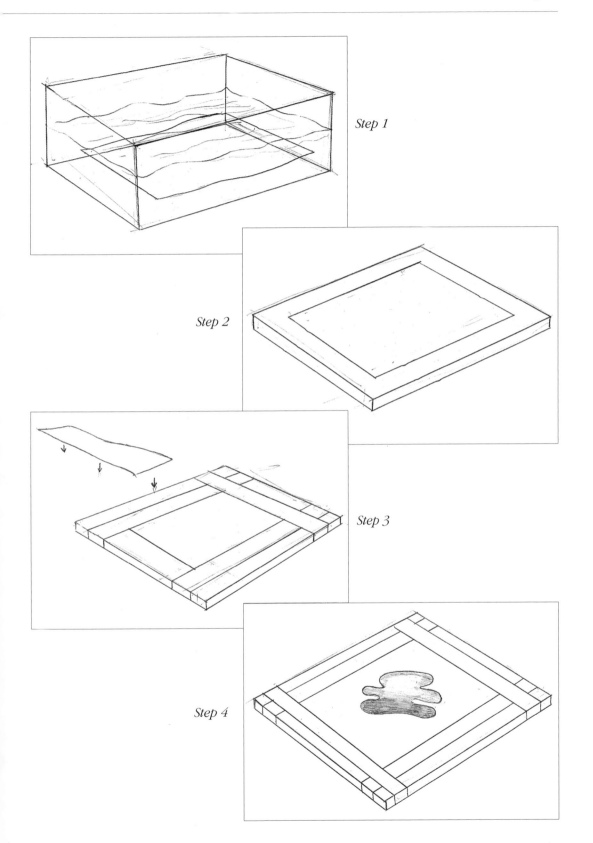

Step 1

Step 2

Step 3

Step 4

CORRECTION

Before correction fluids and pen became widely available on the market it was very difficult to correct a pen, brush, and ink drawing. One used a Chinese white, which was zinc white prepared paint that was painted over the offending area. However, the stain from the ink would often keep showing through. You could also remove the mistake from the paper by using a razor blade or a pumice stone. One could only use this method if the paper was durable enough. However we thankfully have modern correction fluids and pens that will cover the strongest of marks without any problems, and they are permanent. The pen can be used to cover very intricate work and as a drawing instrument in its own right. The applicator can be used to cover very large areas where radical changes are needed in a drawing.

THREE TYPES OF DRAWING WITH INK

Bleach wash drawings Some very interesting results can be achieved by using fountain pen ink. You must first stretch the paper on which you are about to do the drawing, then cover the whole surface with a liberal coating of ink. Allow this to dry. You can now paint different solutions of bleach onto this surface. An important point to remember is that the stronger the bleach the lighter the areas will become. Before embarking on this technique, you should make some practice drawings to experience the unusual effect first-hand. For examples of this type of drawing, see page 199.
WARNING: Please remember the health and safety aspects when using chemicals: always read and follow the guidelines for use.

Pen, brush and ink drawings For this type of drawing you should first draw the composition out very lightly with pencil. Make the appropriate marks to describe the scene and then correct any mistakes. If you are happy with this initial drawing, go over these marks using your dip pen. Always try to recreate the varied use of mark already there, then proceed to go over the drawing with washes to give it its tonal base.

Pen, ink, brush and correction materials As in the previous section we are going to use correction materials as a positive element alongside the other materials.

EXPERIMENTAL MARK MAKING WITH INK

Try to approach this without any preconceived ideas about what the marks should look like, as there is no formula or recipe for this way of working. It is a way of making a personal vocabulary of marks that can be used as references for future drawings. I can explain how I made my examples but it is very important that you expand upon these and discover your own natural method of working. You can use any type of ink; I used Indian ink. The implements used were chosen at random, just to give you examples.

1/ A feather or quill

The first few marks have been made by dipping the pointed end (ie the non feathery end) into the ink and applying it to the paper. Drag the end of the quill across the paper, applying different pressures and moving the quill in different directions. Then try to make dots with the quill end. You will find that you need to replenish the ink quite frequently for these procedures. Now try dipping the feathery end of the quill into the ink and work the ink across the paper by dragging allowing the ink to naturally thin out from very dark opaque marks to lighter thinner textured marks.

2/ Shaped piece of stick

I chose a planed piece of wood about an inch thick. At the end of the piece of wood I've cut three channels with a sharp knife making a row of jagged teeth. I dipped the teeth into the ink and then made different types of marks with the wood by dragging in different directions and with different movements across the paper. You will find when you first apply the stick that, as with the feather, you will make a more opaque line. This will gradually thin out to a series of lines that become less dense in tone as the ink thins.

3/ Piece of dowling or a circular end of a piece of wood

Simply dip the end of the piece of wood in the ink and imprint it onto the paper, creating a sequence of dots. You will notice the dot impression fade as the ink runs out.

4/ Stippling brush

This brush is designed to make a mark known as stippling, a technique used in ceramics, painting and decorating as well as by fine artists. Dip the brush into the ink; then wipe off the excess on the edge of the bottle. Holding the brush vertically, dab it onto the paper.

5/ Cotton bud

The cotton bud is a very useful tool for drawing with ink. Strip the cotton wool off one end of the bud and, using a pair of scissors, make a diagonal cut across the stem to give a pointed end. This end can then be used for making marks smilar to the type you would get with a regular dip pen. The hollow stem of the converted cotton bud will hold a certain amount of ink, just like the reservoir of any pen. However because the ink in the stem is very free flowing, this implement can be used to achieve a splatter effect, by making a stabbing motion. You can also use the other end of the cotton bud. Dip this into the ink and you can make thicker heavier lines or tonal areas varying from black to grey.

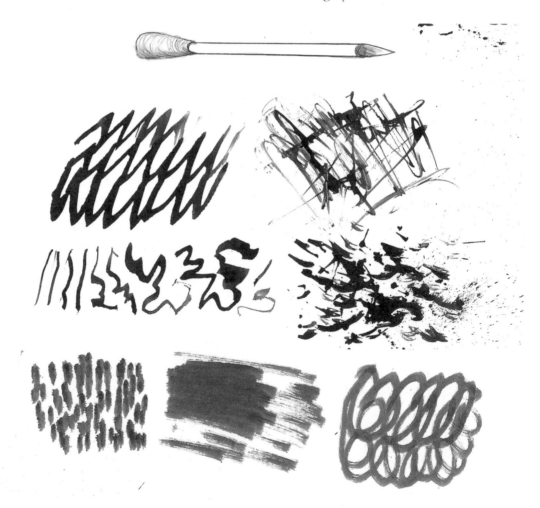

6/ Toothbrush

Take an old toothbrush and dip that into the ink. Aim it at the paper and then pull your thumb over the bristles of the brush, firing speckles of paint at the paper. In this way you can build up areas of tone out of this speckled effect. You can also use the brush to apply the ink as though you were drawing with it.

7/ String

Take a frayed piece of string. Ensure that the frayed area is quite tough and resistant. Dip this into the ink and apply it to the paper, using different hand motions to create a variation of marks.

DRAWING WITH STRING

This drawing is based in memory and imagination, two elements that are very useful resources for artists to draw upon.

If we start at the top of the drawing, you will notice that I have used the string in a twirling motion to give the effects of leaves. Sometimes I have built up the tonal areas by making them darker and sometimes I have made areas lighter to give the effect of form and space. The trunk of the tree has been created by dragging the piece of string up the line of the trunk to create the effect of bark. The grass in the foreground has been produced by dragging the string in short waves in different directions. The space in the background has been achieved by making just a few varied marks to imply distance.

THE ORIENTAL BRUSH AND ROUND HEAD BRUSH

Oriental brushes are traditional brushes used in Chinese and Japanese drawing and calligraphy. The brush was traditionally used by holding it vertically to the paper and making the marks with free rhythmical strokes. The control in the mark, and the varied weight of mark, are achieved by varying the pressure on the brush. The amount of ink the brush is holding will also have an effect on the nature of the mark. As you can see some brush strokes are strong in definition and some are more textured - others are tonally lighter and more sensitive. In the example shown on page 176, notice the artist's signature – there is

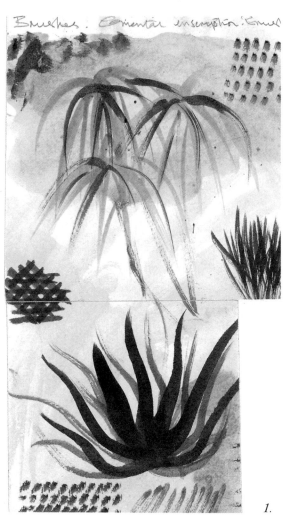

1.

the same tension in the calligraphic mark. Although a history of mark making is evident in this brush work, the drawings themselves appear to be expressive, and have a sense of movement and natural rhythm. They are dynamic drawings governed by a strict tradition of mark making. However, you should not be restricted by the traditional approach. Hold the brush in a way that is comfortable for you and make the brush strokes without any preconception of what might occur. You will learn most by taking this approach.

In the following series of examples you will see that there are different degrees of freedom in the kinds of marks made.

1/ In the first example, the mark is loose and free-flowing mark with some control. The marks that imply leaves or grass are where the body of the brush is placed onto the surface of paper and gradually pulled in an arched direction whilst gradually lifting the body of the brush away from the paper. Other marks to create natural forms such as grass can be made by putting the point of the brush onto the paper and dragging it across the surface for a short distance in a series of slightly differing directions.

You can create a series of dots by placing the end of the brush onto the paper. Rows of vertical and horizontal marks can imply texture, perhaps a weave or a basket, or could be used to suggest windows in a building.

2 & 3/ Here the marks are made slightly quicker and imply more rhythm and freedom, although there is still an element of control in them.

4 & 5 (overleaf) The control of the brush in these examples is very limited. The accidental spillages add to the dynamics of

the calligraphic effect (the free and rhythmical treatment of a drawing).

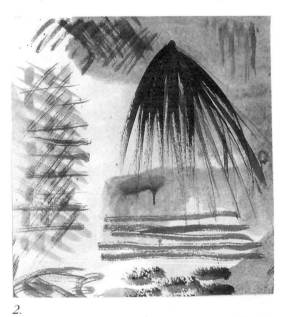

2.

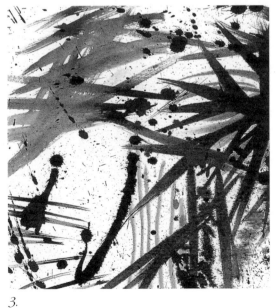

3.

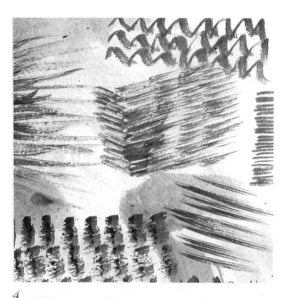

4.

5.

For the examples of splatter technique shown on the opposite page, I used round head brushes; Oriental brushes are also suitable. We can see that control in making the mark has been removed, so what you end up with is largely dependant on chance. The accident in making art has been positively used by many, or even most, artists in their work, particularly contemporary artists. We have only to look at the work of Jackson Pollock and other abstract expressionists, the drawings of Ralph Steadman, Richard Diebenkorn and, in the past, Rembrandt, Delacroix and Leonardo da Vinci to find examples of this approach.

To make a splatter simply load the brush with ink, and throw the loaded brush at the paper. You can use any ink. When you first attempt the technique, the splatters should be random. However, like Jackson Pollock, once you become experienced, you can start to use it with more direction.

The idea behind the splatter technique is that it breaks down the artist's preconceived notion of what a drawing is and how it can be done. You should find that it puts you more in tune with the emotional side of your creative nature, and helps you to expand your ability to discover how accident can be a means of expressing an idea or observation. Imagine looking into the sky at a cloud formation and seeing something that you recognise as an image. This is a perfect analogy of splatter technique.

Examples of splatter technique.

*Drawings made
with a round-
headed brush.*

FLAT HEAD BRUSHES

The flat head brush has been fundamentally designed to lay down washes but at the same time it is a very useful tool for making broader marks. Washes are areas of tone that are put down onto the paper. They can range from very light, thin and transparent to dark and opaque. Washes can be used to describe atmospheric effects, typically in landscape drawings. When used in this way, they are usually applied very freely. Sometimes they have a life of their own when they are spread on the paper. You shouldn't worry about this, but try to learn how to manipulate the effect. To make a wash, dilute the ink with water.

Marks made by the flat head brush. These were made by dragging, twirling and stippling with the edge of the brush.

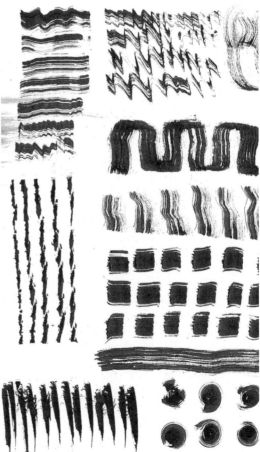

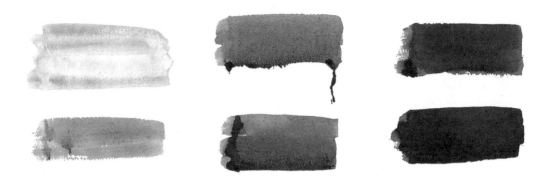

The more water you add the more transparent and thinner the wash will be. The wash is applied by dipping the brush into the ink and applying it in an even coat to the appropriate area. Washes can also be used in a more formal way, to create the illusion of form. This is done by a transition of tone over the object, putting one side of the object in light gradually tonally changing to the other side of the object which would be completely dark. In this type of work you have to take into account the shadow cast, which is also dark. You can see an example of this on page 181, where a sphere has been constructed using a series of washes. A series of broad marks made by the flat head brush are shown on page 177. These marks are made by dragging, twirling and stippling with the edge of the brush. These are just a few examples As with all experimental mark making you should try to expand your repertoire by experimenting with how you use the brush.

WET INTO WET

Another way of using the flat head brush and other brushes is to paint wet into wet. This is a process which again has its own beautiful life force. To make a wet into wet mark, dampen your paper (the wetter the paper is the more the mark will spread of its own accord).

1/ A wet area has been left on the paper. The ink-loaded brush has then been allowed to touch this wet area to create a flower-like spreading effect. Either a round head or Oriental brush can be used to achieve this.

2/ The paper is not as wet as in the previous example, but the same brush is used. The paper has been touched repeatedly. Lines have also been drawn across the paper. You can observe that the spreading is not so radical as in **1**.

3/ The flat head brush has been used here, and the conditions are the same as in **2** except that we have immediately blotted the drawing with another piece of paper to stop the ink spreading.

4/ The paper is not as wet as in the previous examples and is only damp. The flat head brush loaded with ink has been placed on the paper on its flat broad side to make the marks. You can see that the spread of ink is very limited and more congealed. These types of marks should be used to imply textures or objects such as flowers.

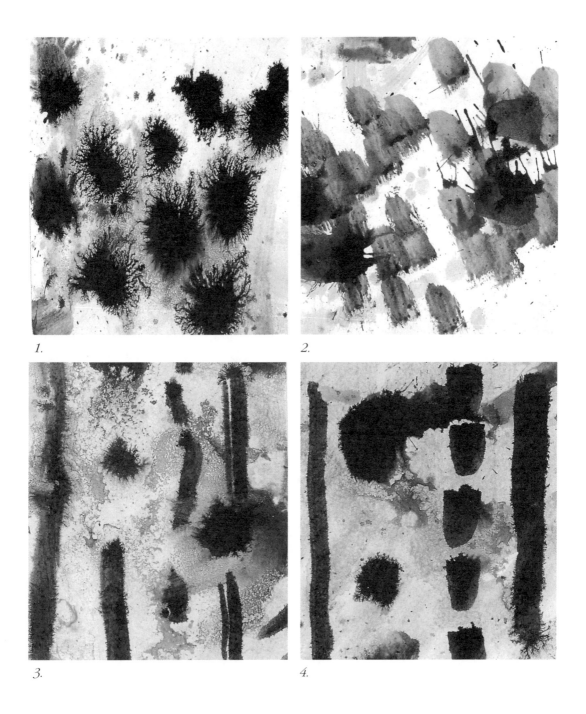

1.

2.

3.

4.

CREATING THE ILLUSION OF FORM

As with some of the earlier examples in the previous sections I have here shown other methods using different pen, ink and brush techniques to create the illusion of form on a two dimensional surface.

The first method I have used employs a flat head brush and a series of washes to give the illusion of a sphere. Firstly draw the sphere outline and horizon line at the back to create the composition. Draw also the shape of the shadow. Start by using the Indian ink in the most dark and opaque areas, that being the shadow, a small part of the underside of the ball and the area above the horizon line at the back of the ball. Dilute some of the Indian ink to create a slightly lighter wash and place this next to the dark area that is on the sphere, gradually diluting and spreading the tone over the sphere until it becomes completely light at the opposite end.

The illusion of a cube is created by a controlled splatter technique using a toothbrush. First draw the cube out lightly using a pencil, not forgetting to put the back line in to create the sense of space. Then mask out the areas surrounding the darkest side of the cube, leaving that area the only area open to the splattering. Take the toothbrush and dip it into the ink. Make a test example first of all to ensure a smooth and consistent area of ink is applied, and when you are happy with the result turn the process to the exposed area on your drawing. When this has dried do the same with the mid tone area by masking around that and then applying a mid-tone. Wait for it to dry and the using the same procedure do the same for the last, and lightest tone.

Create the illusion of a cone by the use of front light shading with a fine felt tipped pen and correction fluid. As with the other two solids draw the outline with pencil first very lightly and place the back line in. The nearest point of the cone will be the lightest area and as the surface of the cone gradually goes back the tone will become darker. In this drawing I have used correction fluid to make the lighter area on the drawing appear even lighter. The dark areas have been created by using a series of lines that follow the curve of the form. These lines become denser and darker as they begin to reach the outside edge of the form.

Create the form of a cylinder by the use of a rapidograph or rotring pen. Again draw the outline of the cylinder with a pencil, and the back line to create the space. On one side of the cylinder draw a series of vertical lines. Start with them being very close together giving the sense of a shadow. Gradually space the lines out so the other side of the cylinder is completely white. Now repeat this process on the top of the cylinder but from the opposite side - this gives the illusion that the cylinder is hollow.

These are just a few ways to create illusions of the 3D effect. You should think of other methods that might be employed to create similar illusions, and try them out to expand your visual perceptions.

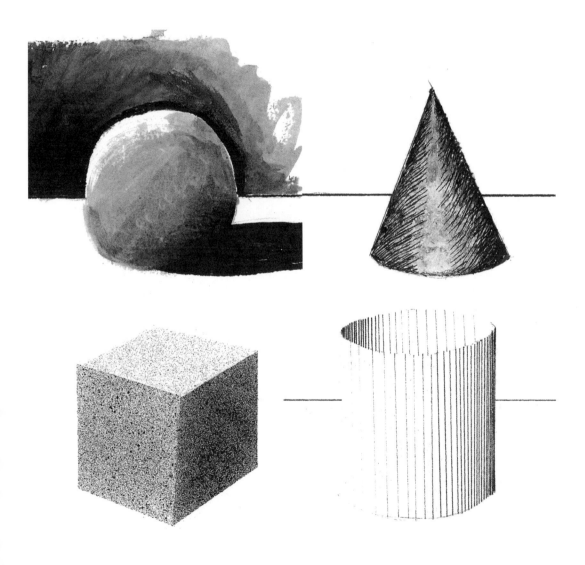

You can clearly see the 3D effect in these examples.

ROTRING OR RAPIDOGRAGH PEN,
FELT TIP AND FIBRE TIP PEN.

Artists who have been specially trained often create drawings with these pens. These people are usually architects who have studied the subject at university. I am showing these examples as something that you might aspire to in the future when you have had more experience at drawing, rather than attempting them now.

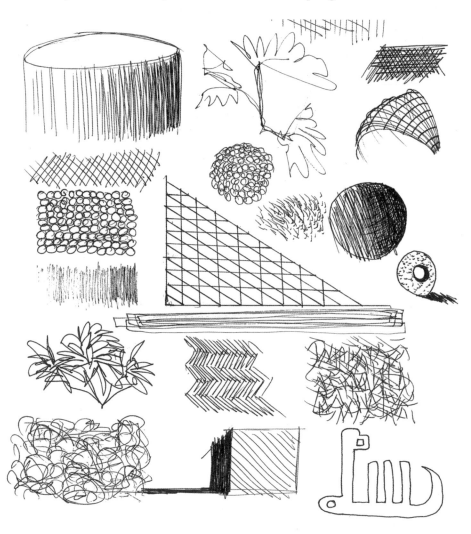

FELT TIP PEN PROJECT
DRAWING OF A HARBOUR

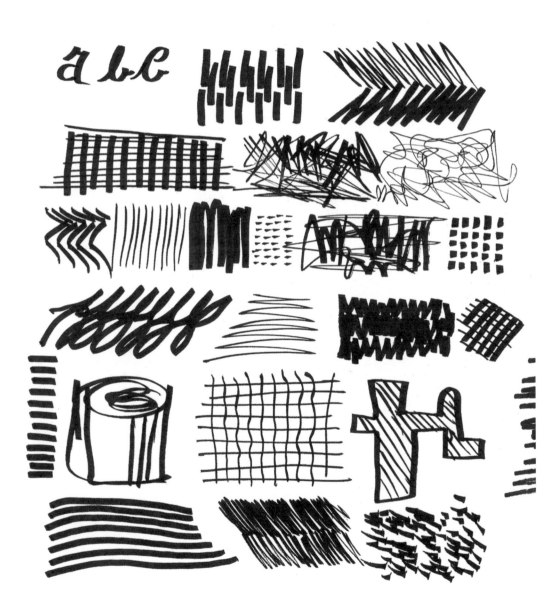

Start this drawing by drawing the composition first with pencil. That way, if you make any mistakes you can rectify them by rubbing them out. To establish the composition or the drawing on the paper, use your previous learning. For example, use the window mount to help you frame your picture. As you look through the window on the world move it about to establish a composition that you are happy with. Then draw what you see through the window on to your paper, placing and mapping the objects in the scene relative to the proportions of the paper. The drawing on the paper should mirror exactly what is seen through the window mount but on a lager scale (see the

example of the rough pencil sketch).

Now you have established your composition you can begin to draw over the pencil lines with a felt tip pen that is best for making lines. With this pen one can also imply the idea of texture, as shown in the drawing on the doors of the warehouses. One can also make tonal areas with this pen. In the drawing I have made tone by using a series of parallel diagonal lines at the foot of the buildings to give a transparent impression of glass or shop fronts. To give a sense of the windy weather I have drawn the clouds with a rhythmical squiggly line that gives the impression of movement across the sky. Plus the drawn line which implies the telegraph wires has been

drawn as though it too is being rattled by a gusting wind. This line too is rhythmical, but it has a different tension to it than the lines that denote the clouds. The railings are drawn by one long horizontal line for the top and a series of small vertical lines spaced evenly.

The sea wall is indicated by drawing a series of irregular squares and oblongs that express a brick pattern. To draw in the windows I have used a felt tip pen that has a square chiselled end to it, and it is the right proportion to make just the scale of mark that I need to put in the widow tone. Where there are four window panes I have made four marks with this pen leaving a slight gap between the marks to indicate the window

frame, and similar with the other windows. In the foreground I have used a much thicker pen to make bolder and stronger marks so they appear to come forward in the picture space. Some of these marks are very regular and follow the form of the boats to give the impression of the wooden planking that the boats are made of. Other marks are more free-flowing to give the impression of the sea lapping up to the shore, and other areas are made up of dots to give the impression of the beach or the shore. The windows on one of the boats have been drawn by toning them in and just leaving a few white spaces to give the idea of reflection.

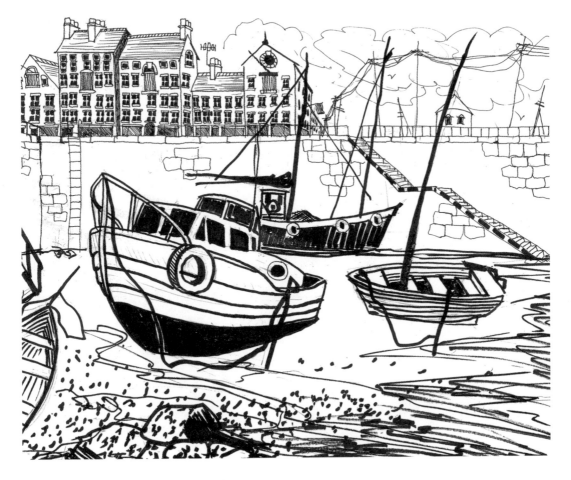

**CORRECTION FLUID TEXT FOR
ILLUSTRATIONS**

1/ Correction fluid comes in a small plastic bottle and the applicator which is like a small brush is attached to the top of the bottle. To use the fluid dip the brush into the bottle and then apply to the appropriate area. One usually uses this type of application to cover larger areas.

2/ Correction pens are made of the same fluid but the applicator is in the fashion of a ballpoint pen. Therefore it is more suitable for correcting fine work, and can also be used to draw with, making a white line on a dark background.

3/ Chinese white is the traditional form of correction fluid. Chinese white is a white water-based paint that one applies over the offending area using a brush. It is not as good at covering the mistake as correction fluid.

Following are two drawings done after Picasso using correction fluid and correction pen - not as a correction fluid but as a drawing tool. As mentioned before in previous chapters, correction materials can be used as a positive part of the application. I have copied two drawings by Picasso. It's standard practice for beginners to copy the great masters and these drawings very much lend themselves to the use of correction fluids. Start by choosing an appropriate drawing for this project. The drawing should contain light and dark contrasts plus the use of white lines over the dark areas. Set yourself up with the materials. This should consist of a piece of paper that has been stretched, because we are going to put down some washes. You also need a flat headed brush to put the washes down, a pencil to lightly draw the composition, a dip pen, Indian ink, and some water to dilute the ink to make some thinner washes.

Start by taking the pencil and lightly sketch in a copy of your chosen artist's work. When you have finished this and you are happy with the composition you can draw over this with the dip pen and ink. After this

Tippex fluid.

Tippex pen.

Chinese white.

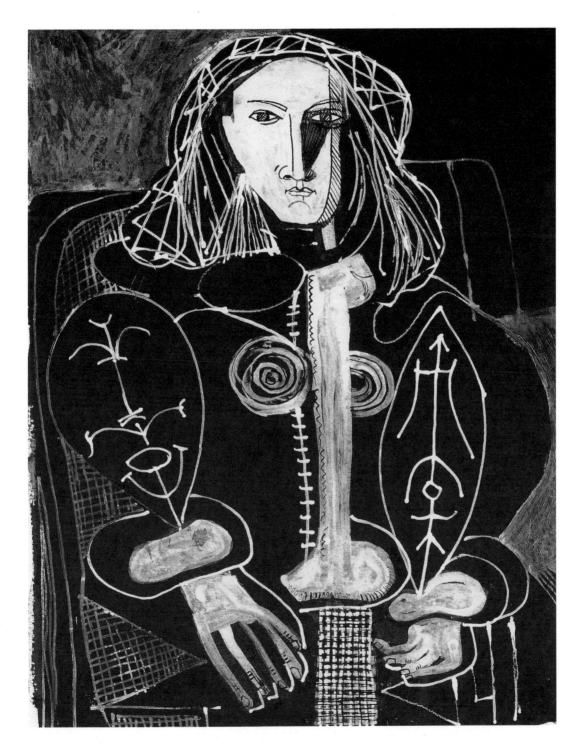

start to put in the tonal areas. Lay the darkest tones down first, followed by the thinner lighter tones. To make the lighter tones, put a little water in a dish and add some ink to it, then test the strength of the tone you have made by brushing this fluid on a practice piece of paper. If you need it to be darker then add some more ink. If you want it to be lighter then add some more water. Keep testing the strength of your tones before you apply them to your drawing. When you are applying them to you work your aim is to copy where the tones are on the original drawing. If you make some tonal areas too dark your can lighten them by putting down a layer of correction fluid over it. You can cover the area very opaquely and then lay another wash over the top again to get it right. Alternatively, one can try to brush the fluid

onto the area in a less opaque manner so the tone underneath still shows through and you have achieved the right level of tone. If the tone you have put down is not dark enough then you can wait for it to dry and then put a darker tone over it. You should now have a tonal drawing that has little or no evidence of line as it will have been obliterated by the tonal overdrawing. You are now in the position of putting down the lines with both the dip pen and ink and the correction pen. Over the white and lighter areas, draw the line with the pen and ink, copying the dark lines that will show up in contrast against the lighter areas. In the darker areas start to draw your lined image with the correction pen. This will produce a white line that will show up in contrast with the darker areas. See the copies of the Picassos' that I have done.

USING A DIP PEN AND INDIAN INK FREELY (EXPRESSIVELY) AND CONTROLLED (FORMALLY)

The dip pen and ink together are very versatile materials they can be used expressively to produce line and tone drawings. This type of drawing is sometimes referred to as gestural drawing, because it is quick and a lively type of drawing. It is done with speed, and tends to capture movement and rhythm in a drawing as well as form. It can also be used as a very controlled formal material using line and tone to produce very accurate drawings that render form - these two styles can be combined in the one drawing. In the examples you can see the difference between the two types of drawing. I have drawn some details of the body. In the drawings of the hands the first example shows the gestural approach to the drawing. It has the appearance that it has been drawn very quickly trying to capture the structure of the hand. The second drawing of the hand has a more controlled response to the observation. The observation is an analytical breakdown of the hand, using a series of shapes to express an understanding of the hand. The third drawing is a mixture of the two styles – formal to provide a basic structure to the drawing, overlaid by some gestural drawing to help the sense of movement and rhythm.

1/ is a gestural drawing

2/ is a very formal drawing expressing the idea of form. The crosshatch, which is a series of lines that run parallel to each other and can be over laid to build up the density of tone, has been used on this illustration to express the illusion of the form of the head. The tone has been put where you would normally find the tone situated on the head.

In the third illustration there is a mixture of styles. The same is true for the drawings of the foot and the legs.

1/ is the formal approach **2/** is the gestural approach, and **3/** is the mixture of the two styles.

PEN, INK AND WASH DRAWINGS

A pen, ink and wash drawing can be appropriate for any subject - still life, figures, interiors - but I believe it is best suited to landscape work, because of the atmospheric effect one can create with the washes and the textural marks one can make with the pen. For this landscape drawing, you need to stretch a piece of watercolour paper to absorb the washes that are going to be put on the paper. You will also need Indian ink, water, a dish to mix the washes in, a dip pen, a pencil and a flat-headed brush to apply the washes. As

with all these drawings choose your composition using a window mount to help you in this decision making. When you are ready, draw your picture outline lightly using your pencil, drawing the contours of the land, the outline of the buildings and the trees, and any other objects in the scene. Then begin to draw and imply the textures such as the brick work on the buildings, the leaves on the trees, the grass and plants, the stone walls and so on.

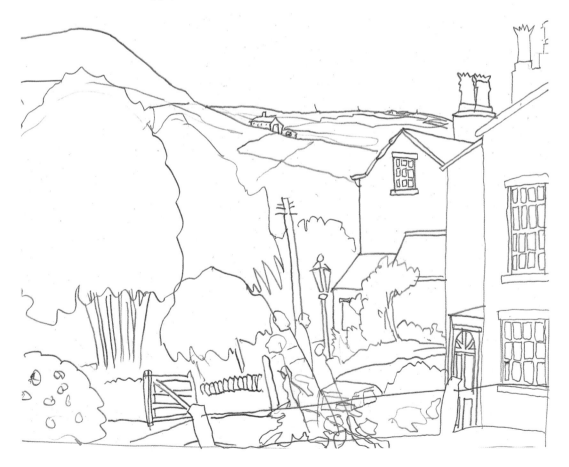

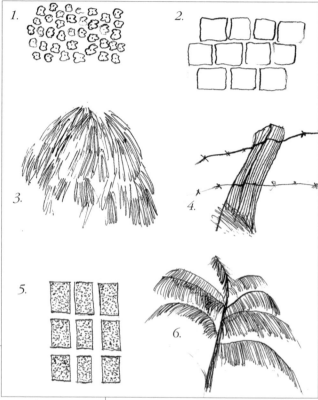

1/ implies the idea of flowers - the mark consists of a series of buckled circles with a dot in the middle.

2/ three rows of stagger squares gives the impression of the stone work on a cottage.

3/ Bunches of squiggly lines that are placed close to each other so as they overlap gives the impression of a type of tree.

4/ the outline of a post has been drawn and then filled in with a series of parallel straight lines. This gives the impression of wood

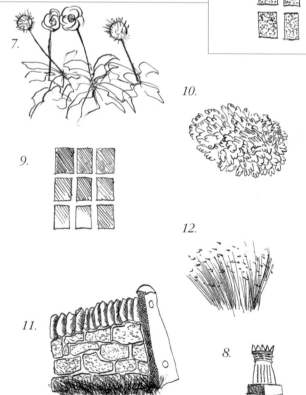

5/ the windows in this instance have lots of dots that give the impression of a curtain behind the glass. When you are happy that this is correct, you can then start to work with the ink and pen.

6/ in this illustration there is the trunk of a tree and the branches - a series of downward marks gives us the idea as to what type of tree it is.

7/ the variety of lines tell us about this flower. At the base of the flower, a free flowing line indicates the type of leaf. The stem is a straight line that implies the direction of the growth of the plant. Whilst the circle with the spikes protruding from it tells about how the plant looks when it is about to seed. The other arced marks within the circular centre

indicate how it flowers.

8/ here are a series of marks that inform us of the structure of the chimney pot.

9/ a row of oblongs with diagonal marks of varying density give the impression of reflections in glass windows.

10/ a rounded W mark which is put down at random appears like a type of leaf.

11/ a series of shapes to imply a stone wall and post are then filled in with marks that imply the texture of the wall. Tonal crosshatching has been added to give the illusion of form.

12/ a series of quickly made directional lines with a small flicked mark at the top give us the visual understanding of a type of grass.

Your aim now with the pen is to load it with ink. Dip it into the ink, and in the first instance make some practice marks on another piece of paper until you achieve the right flow of ink from the pen to create a steady, even flowing line. Now you can begin to draw the line over the top of your pencil drawing, replicating the marks you have made with the pencil. Over the top of

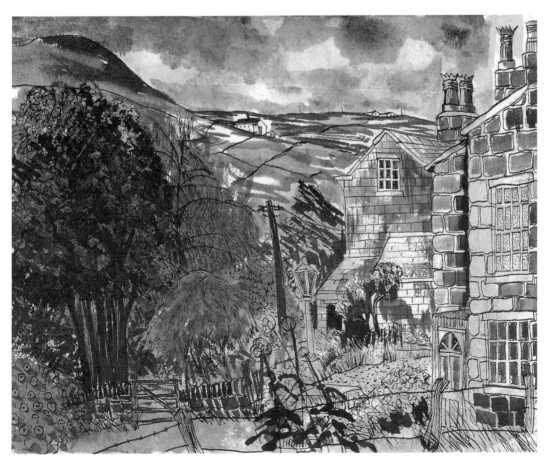

this, you now need to lay down the washes using a flat head brush. The washes will give you the tonal contrast in the drawing. I suggest that you start with the lightest tone first because if you do not make the tone dark enough at the first attempt you can always add to it to make it darker. If you work the other way round it is more difficult to correct, and you will have to use correction fluid to cover up your mistakes. I have chosen a landscape for my example as I think landscape is very suited to this way of working with washes and pen and ink.

The washes for the picture should be mixed with water in a dish. The more water that is added to the ink the thinner the wash will be, and therefore the lighter the tone. So when you have mixed your first wash try it out first on a piece of paper, to see if you have the appropriate tone for that section of the drawing that you are going to put the tone too. In the first example, you can see that there are six tonal washes that range from a very light transparent tone, gradually getting darker until in the last tone we have a black opaque tone. In the next example,

there is a similar tonal transition but instead of these tones being separate there is a gradual continuous transition. Remember that this drawing is based on the observation of the landscape and that the light in the landscape can rapidly change so be prepared for the changing light. When you have made a commitment to an area in the drawing remain with it or you will be forever changing it. A good suggestion is to limit the amount of tones that you are going to work with in the drawing. Say a range of five tones ranging from black to the white of

the paper, leaving you with three tones in the middle of varying greys from light to dark. One can pre-mix these tones to work quickly capturing the changing nature of the light. Once you are ready to start all you have to do is to put down the tones on top of your pen and ink drawing in the appropriate area. When I go out landscape working, I tend to take a number prestretched papers to work on to get the most out of the day's excursion.

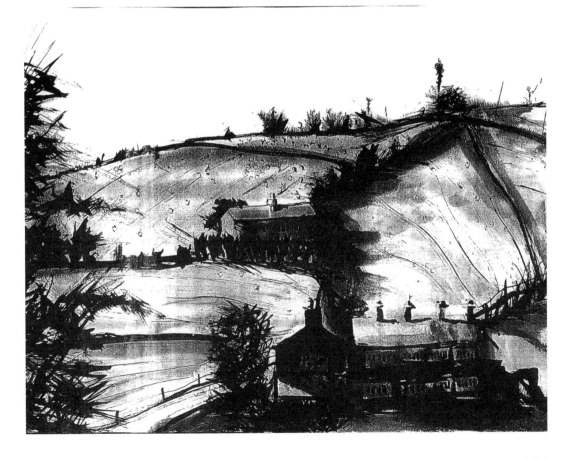

BLEACH WASH AND MARK MAKING DRAWING

This is a very striking way of working, in that it brings such a luminous effect to the drawing. Drawings using this medium rely strongly on the effects of light.

For this exercise you will need a selection of brushes that you think are appropriate to the marks you need to make. You will also need to stretch some paper because in the first example we are going to cover the surface of the paper with ink. Indian ink will not do for this work as when it dries it becomes waterproof and therefore permanent. I use a product called Quink, which is soluble in water and does not dry permanent. When bleach is applied it affects the ink by bleaching out the colour and leaving a bright stain that gives the dynamic effect of light against the dark of the ink. This approach to working is the opposite of what we would normally be doing - in effect we are adding the light rather than adding the darker tones.

To start, cover the paper with ink. For the first trials let it dry. Then take the bleach and dip one of your brushes in it. Make some test marks, the test marks in my example rather look like Chinese calligraphy. You can practice as much as you want before you do a drawing. Get to know the potential of the process. However be aware of the health and safety aspects of using such materials as bleach and follow the directions that have been put on the product to protect yourself.

In the first drawing of the portrait I set the sitter up so there was a strong light coming from one side. This gave me a strong contrasting tonal subject. I then dipped the brush into the bleach and started to draw in the strongest areas of light, and like magic the light and luminosity appeared. When you first do this drawing the effect is quite startling, it's like doing a drawing in reverse. My next step was to put in the tones that were of the middle range. To do this one dilutes the bleach with water to take away its strength. Practise before putting down the next tone on a piece of prepared practice paper so you have the right strength of mix to give the right tone. The two landscapes are done through the power of suggestion - a process I have mentioned before with the images you see in cloud formations. The same process is applied from the beginning, and that is to lay down the wash of ink in the first instance. However, before letting it dry, paint wet into wet with different strengths of bleach. As a suggestion do this in the area at the top of your paper to suggest the sky. At the bottom part of the drawing I have allowed the ink to dry to work into it in a different way giving a contrasting mark in the drawing. Other techniques I have used to make marks in this drawing have been splattering the bleach on to the paper with a toothbrush, drawing lines with a dip pen with the bleach, and laying diluted areas of bleach down to vary the tonal aspect of the drawing. As I explained earlier, this drawing has been done from autosuggestion rather than observation. However, there is nothing to stop you from doing a drawing in this medium from observation.

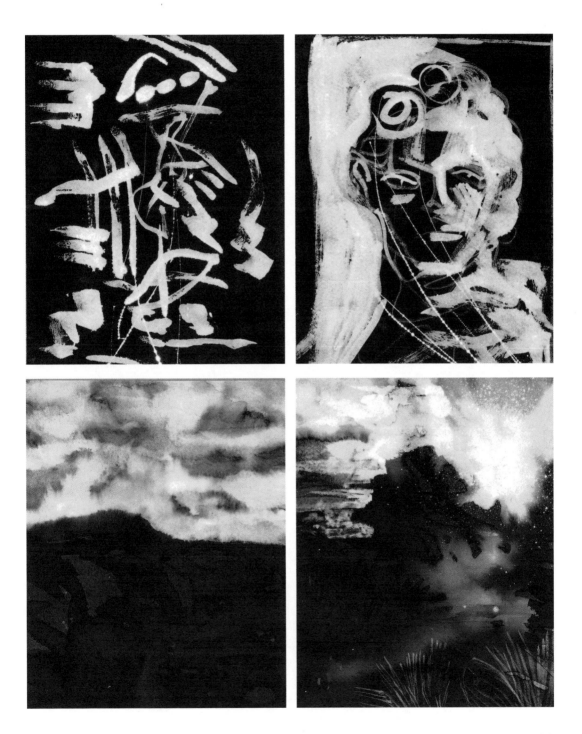

THE BALLPOINT PEN

On this page you will notice a series of doodles with the ballpoint pen. Starting in the top left hand corner I will describe the top line of marks, and explain the type of marks. However, bear in mind that many drawings done with this type of pen are from the subconscious mind and are really scribbles that are made whilst we should be focusing our attention elsewhere. We usually do these drawings in boring meetings or on the phone pad when we are having a long conversation with someone.

The first mark is a circular scribbled line that proceeds down. The second doodle is a gestural line drawing of a head. Next to that are a series of small vertical lines, with a series of horizontal lines crossing them. Then next to that is an unbroken line that moves sideways across the paper getting lighter as it reaches the other end. Then there is a strange little star with feet followed by two forms drawn with line and then a squiggly line drawn down one side to suggest tone. That is what happens on the top line of this sheet. There are no hard and fast rules that apply to making doodles - you just do them and enjoy doing them. Ever since man has made his mark on the cave wall or in the earth we have instinctively jotted things down whether representational or not. This is just the modern day equivalent of that need to make a mark, and a lot can be gained from it that does not have preciousness to it and sometimes does not have meaning to it. See it as a natural experience that comes from the instinctive act of drawing.

THE FIBRE TIP PEN

On this page there is more order to the marks. From the top left there are a series of different marks that have been made with the fibre pen. The first mark is an open squiggle of a line that has a sense of rhythm and movement to it. It is a flowing line but it has a certain speed to it. At the end of the row is a very similar type of line but it appears to be a faster line. Therefore, two lines that are similar in nature have a different idea or sense of time to them. In the middle of the two squiggles is a series of parallel vertical lines – one gets sense that these too have been done

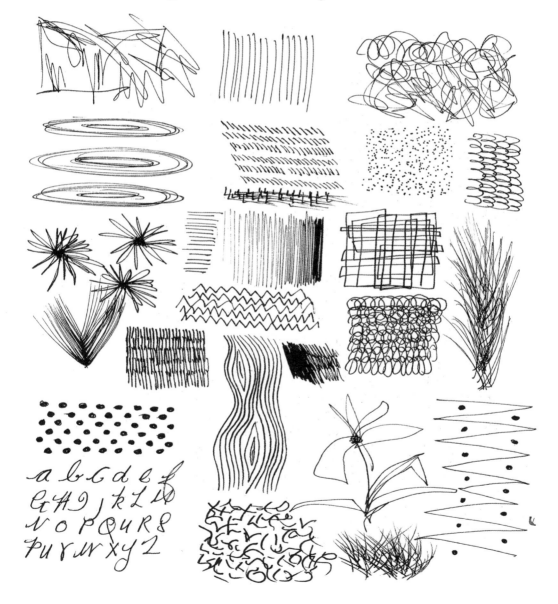

quickly suggesting an action to the mark. At the beginning of the next row, there are three circular ellipses that have been done at speed. Drawing quickly enables us to be more relaxed and freer about our approach to drawing. This is a good way of drawing an ellipse, for the very simple reason that all students want to aspire to perfection straight away with one fine beautiful line. However, if there is any inaccuracy in the line it is obvious to the viewer that it is wrong. If however you try to express the ellipse using a number of lines the eye has more options to choose from and usually there will be one of these options that is right. This enables us to feel happier with our attempt. The next series of marks show a series of diagonal marks in rows, which imply a sense of direction, and pattern. Next to this is a series of dots that are made by stabbing the end of the pen onto the paper and this creates a textured like surface.

A number of vertical interlocking curly lines give us a sense of intertwined wire like chain mail. To imply a flower draw a spot for the centre and then make a continuous looping line around the outside of it - and underneath the head of the flower we have a series of closely knitted lines that imply the texture of a certain type of leaf. Then a series of vertical lines where the spacing becomes closer to the right hand side gives the impression of a gradual tonal change. Next to this is a continuous line that forms a series of oblongs to create what appears to be a geometric spatial web. At the end of this row, there are many quickly drawn lines that splay out from a central stem giving the impression of some type of natural form. At the start of the next row, we have five rows of slightly overlapping vertical lines – if you look at these lines from the side one gets the impression of a woven material, like a basket. Then next to that we

have a set of wavy lines that follow each other's direction to give the impression of wood. Above the wood are a series of zigzagging lines that give a jagged impression, and next to that another series of interlocking squiggly lines that imply the sense of a woven type of fabric. Going down to the next row it starts with a series of dot-like marks in rows. In the charcoal section using conte crayon I remember using this type of mark to imply the texture of a straw hat. Underneath the dots is the alphabet. I have always found that the image of a letter is visually very interesting, and so next to this I have used letter-like marks to make an interesting type texture that looks as though it moves or pulsates across the picture surface. Next to that is a continuous line drawing of a flower that is done quickly from observation. The line starts at the bottom of the stem. It rapidly works its way up around and across the shape

of the leaves. It then picks up the stem again until it hits the head of the flower where the line flows around the shape of the petals, finishing off the head of the flower with an intense scribble. The line then finally escapes into space. Underneath this is a series of lines that are drawn in a very direct manner almost with a flick of the wrist. These are short lines that travel in different directions. These marks imply the idea or illusion of grass. Finally the last mark on the page is a vertical zigzag line with dots placed into the spaces on either side of the line. This gives us a clear sense of a pattern. And sometimes when drawing textures, pattern can be an integral part of the drawing. Look closely at the drawing in the book of the garden gloves. The description of the patterning of the texture of these gloves is integral to the making of that drawing.

Fibre tip pen artist's impression.

DIP PEN AND FELT TIP PEN

As with the fibre tip pen one must experiment and here again we have a series of example marks that I have made using these implements. With the fibre tip pen, I have described in detail what these marks have implied. With the following examples (dip pen, thin felt tip and thick felt tip) I have produced for each a page of different marks which you should now be able to interpret. Try to replicate these examples, and expand upon the mark making with these materials.

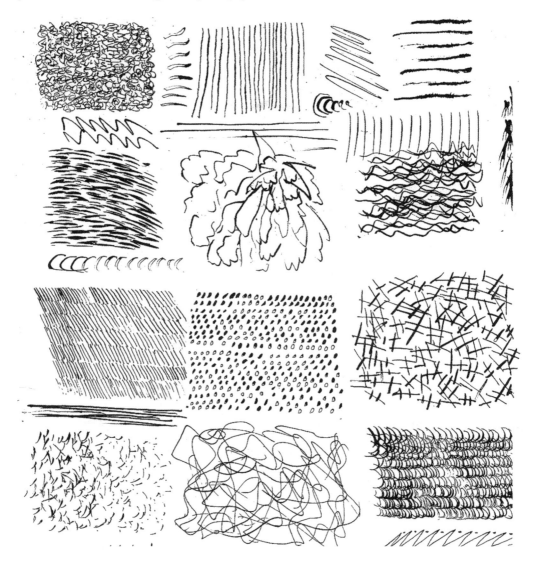

CONCLUSION

Now you have completed all the exercises in this book you will have gained an overall knowledge of drawing. You will have experienced, and know how to use drawing materials, you will know what materials are best used for, and you will know how to approach your drawing. Above all, however, you will have a clear understanding that drawing is about how to communicate your observations, your thoughts, and your ideas in response to nature and the world around us.

P W Stanyer.